The Best of

PHOTOGRAPHIC LIGHTING

*Techniques and Images
for Digital Photographers*

SECOND EDITION

Bill Hurter

AMHERST MEDIA, INC. ■ BUFFALO, NY

About The Author

Bill Hurter started out in photography in 1972 in Washington, DC, where he was a news photographer. He even covered the political scene—including the Watergate hearings. After graduating with a BA in literature from American University in 1972, he completed training at the Brooks Institute of Photography in 1975. Going on to work at *Petersen's PhotoGraphic* magazine, he held practically every job except art director. He has been the owner of his own creative agency, shot stock, and worked assignments (including a year or so with the L.A. Dodgers). He has been directly involved in photography for the last thirty years and has seen the revolution in technology. In 1988, Bill was awarded an honorary Masters of Science degree from the Brooks Institute. He has written more than a dozen instructional books for professional photographers and is currently the editor of *Rangefinder* magazine.

Front cover photograph by Chris Nelson.
Back cover photograph by DeEtte Sallee.

Published by:
Amherst Media, Inc.
P.O. Box 586
Buffalo, N.Y. 14226
Fax: 716-874-4508
www.AmherstMedia.com

Publisher: Craig Alesse
Senior Editor/Production Manager: Michelle Perkins
Assistant Editor: Barbara A. Lynch-Johnt
Editorial Assistance from: Carey A. Maines

ISBN-13: 978-1-58428-217-4
Library of Congress Control Number: 2007926864
Printed in Korea.
10 9 8 7 6 5 4 3 2 1

Table of Contents

Introduction

*L*ight is the key raw ingredient of photography. Even the word photography comes from the Greek words "photos" (light) and "graphien" (to draw, *i.e.,* "to draw with light"). A well-developed knowledge of how lighting works and how best to exploit it ac-

counts, more than any other factor, for the consistent ability to produce fine photography.

The goal of this book is to provide a broad background of information on which to base such an understanding of light and lighting—knowledge you can build into your everyday shooting routine. In the images and observations of the great photographers featured, you will see a wealth of lighting applications that will expand your photographic abilities and, hopefully, persuade you to become a serious student of light, learning from its many nuances and almost infinite variety.

Don Blair, a noted portrait photographer and educator, once said that the photographer who has trained himself to "see light" could look at any photograph and discern precisely how it was lit. Learning to see light, understanding how it works, and appreciating good lighting are at the root of all great photography—but simply appreciating good light is not enough. Truly mastering the technical aspects of lighting is a cultivated discipline that takes years of vigilant observation. And like all complex skills, the more one knows, the more one discovers how much there remains yet to be learned.

Don Blair made a lifelong habit of studying the interplay of light and shadow wherever he went, on all types of subjects, indoors or out. If out for a stroll in the

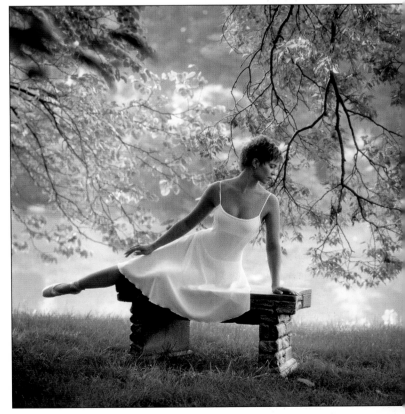

Don Blair was masterful at finding and exploiting great light. Here he utilized a stand of trees to block the overhead light, allowing the light to come in from the side. He used a warm-toned reflector to bounce fill light back into the body of the ballerina/model for a beautiful result.

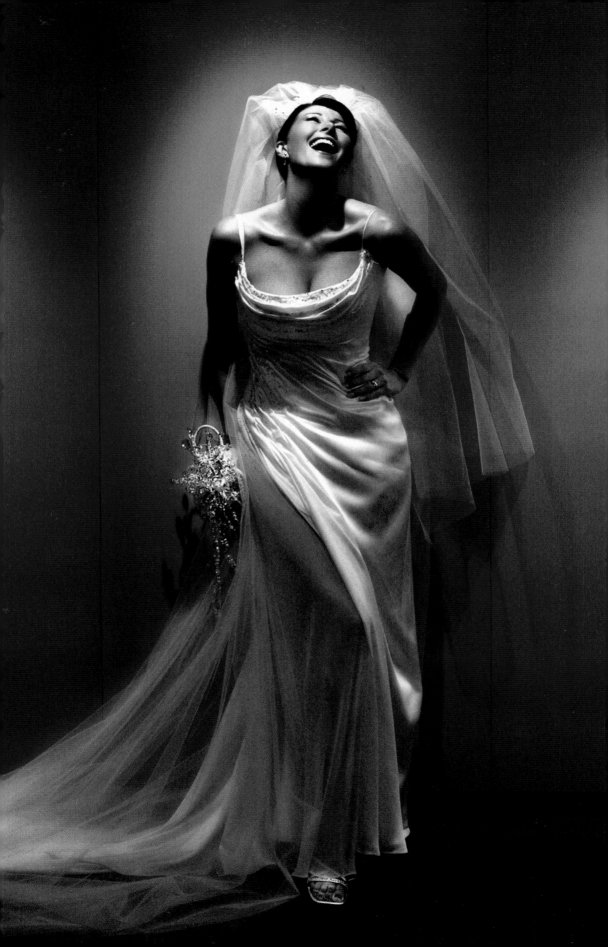

woods, he would study the differences in how the leaves were affected by light. In an interview with noted photography writer Peter Skinner for *Rangefinder* magazine, Don once observed, "Notice the leaves and you will see variations in the color of the new, bright ones in contrast to the older leaves—variations you can enhance by camera position relative to light direction." More than the light's quality or quantity, how a photographer handles these infinite variations is a crucial factor in determining whether, in the end, a photograph succeeds or fails.

FACING PAGE—Yervant used the overhead "can" lighting of a parking garage to produce this signature image. No other light source was used. Yervant remembered the garage lighting and brightly colored wall when he arrived at the site. RIGHT—Light sculpts and reveals hidden textures and beauty. Christian LaLonde captured this beautiful graphic image in the late afternoon when the light scraped across this building exterior creating a textural feast. BELOW—Sometimes nature's light and man's light collide to perfection. Then, the photographer's timing is what determines whether a perfect exposure can be made. Here, Marc Weisberg captured many light sources together in a 15-second exposure just past twilight. The scene is of Alamo Square in San Francisco. The long exposure that was needed to record the tungsten building lights and the mercury-vapor street lights lightened the sky to a twilight level.

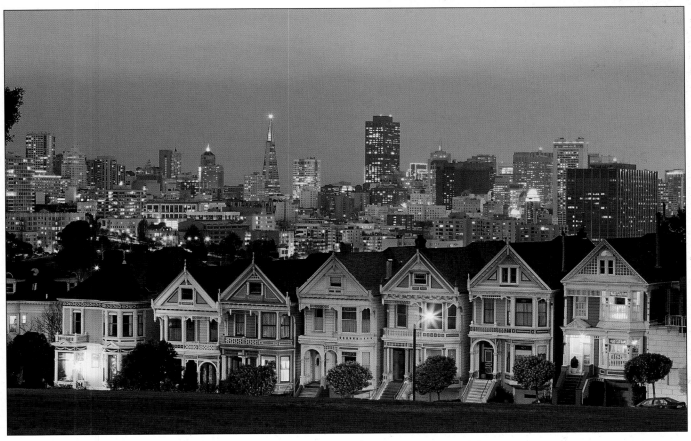

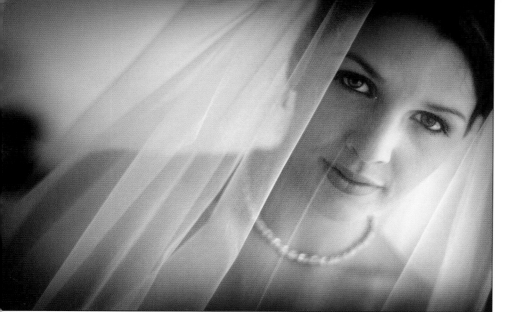

Simplicity Is Essential

Great lighting is simple; most accomplished photographers will agree that lighting should not call attention to itself. Even if you are adept at using five lights in harmony, the impact of the subject is still more important than the impact of the lighting. Often, an elegant photograph can actually be made with a single light and reflector—and nothing more. Ultimately, simplicity in your lighting technique creates greater control over how the light shapes the subject and produces subtle effects, rather than exaggerated ones.

That simplicity is an underlying principle of successful lighting is hardly surprising. In nature, on this planet at least, life revolves around a single sun—so there is only one true light source. As a result, we are subconsciously troubled by the disparity we perceive when multiple shadows, created by different light sources, contradict each other. If, on the other hand, there is a single unifying direction to the light, with a single set of corresponding shadows, we are satisfied that it appears normal.

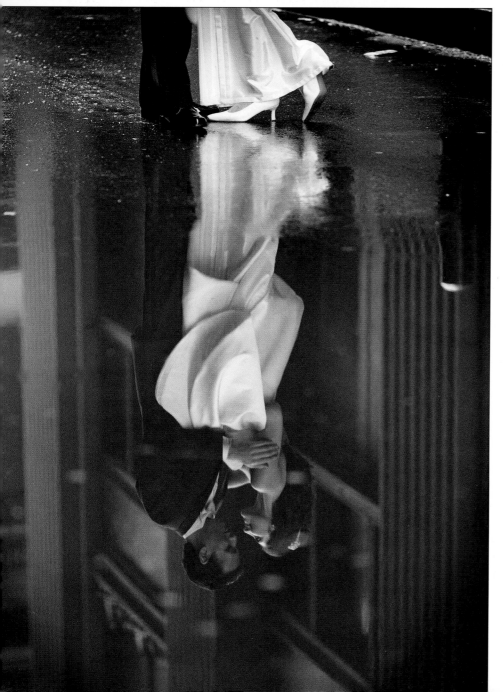

TOP—Light passing through a large window, and again through the mesh of the bride's veil, produces wonderfully soft wraparound lighting that seems to suit the mood of this pensive bride. Photograph by Michael Schuhmann. BOTTOM—Learning to see light sometimes means looking for it in unusual places. Here, Philadelphia wedding photojournalist Cliff Mautner captured a beautiful reflected-light portrait in a puddle.

1. The Science of Light

This chapter is an introduction to light and its behavior. While it is not necessary to understand light like a physicist would understand light, some of the scientific information about light is—forgive the pun—enlightening. After all, it is absolutely essential that all photographers be well versed in the tools of their trade.

What Is Light?

Light is energy that travels in waves. Waves are a form of energy that usually move through a medium, like air or water. For example, imagine the ripples in a swimming pool after someone has jumped in. Is it the water that is moving or something else? Actually, the water in the pool stays pretty much stationary. Instead, it is the energy—the wave—caused by the person jumping into the pool that is moving.

Light waves are different than water waves, however, in that they don't require a medium through which to travel. In fact, light travels most efficiently in a vacuum; other elements, like air and water, actually slow light down. Light travels so fast in a vacuum (186,000 miles

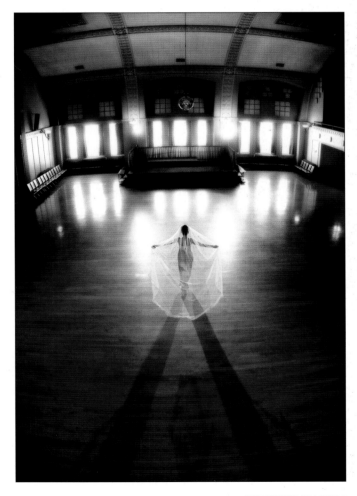

This remarkable photo is by Jerry Ghionis of his wife, Georgina. It was photographed in the Freemason building in Sacramento, CA. There are three light sources at play: daylight streaming in through the windows, house lights sprinkled throughout the hall, and two 500-Watt (W) Lowel video lights pointed directly at Georgina. The latter is what creates the splendid shadows and the effect that appears to make her float in the air. Jerry recorded the image with a Nikon D100 and 16mm fisheye lens at ISO 800 with an exposure setting of $\frac{1}{30}$ second at f/5.

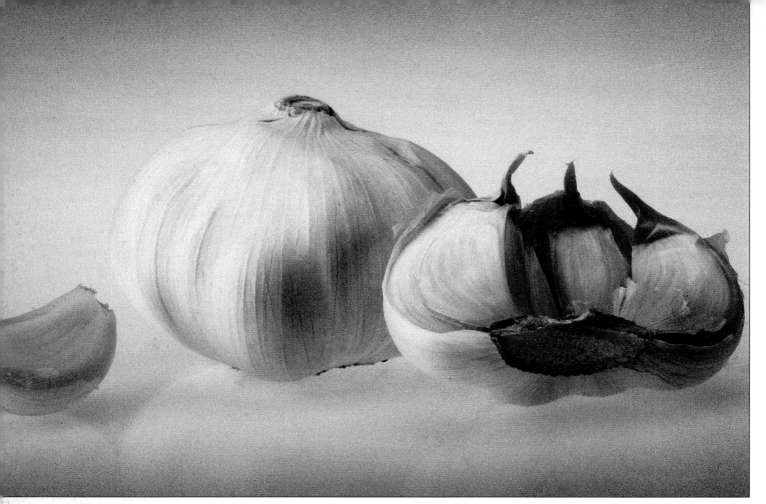

ABOVE—Mercury Megaloudis created this award-winning still life as part of a series of images. The very soft light seems to emanate from within the garlic, making this a truly special image. FACING PAGE—Light, which travels in waves, can be narrowed or widened or altered in a nearly infinite number of ways. Here, a very narrow beam of daylight is made to strike only the profile of the bride. The photographer, Yervant, made sure everything else went black, choosing to isolate just the edge of the bride's face.

per second) that it is the fastest known phenomenon in the universe!

Light waves consist of both electric and magnetic energy. Like all forms of electromagnetic energy, the size of a light wave is measured in wavelengths, the distance between two corresponding points on successive waves. The wavelengths of visible light range from 400–700 nanometers (one millionth of a millimeter). The visible spectrum is, however, only a tiny section of the full range of the electromagnetic spectrum, which also includes radio, microwaves, infrared, ultraviolet, X-rays, and gamma rays—types of waves that are differentiated by their unique wavelengths.

Photons

Photons are the raw material of light. When we see visible light, we are witnessing countless numbers of photons moving through space as electromagnetic waves.

Photons are produced by light sources and reflected off objects. On an atomic level, light works like this: an atom of material has electrons orbiting its nucleus. Different materials have different numbers of electrons orbiting their individual atoms. When atoms are excited or energized, usually by heat, for example, the orbiting electrons actually change to a different orbit and then gradually revert. This process emits photons, which are visible light having a specific wavelength or color. If there are enough photons and the frequency is within the visible spectrum, our eyes perceive the energy as light and we see. Any system that produces light, whether it's a household lamp or a firefly, does it by energizing atoms in some way.

The Behavior of Light

Unless it is traveling though a vacuum, the medium alters how light behaves. Four different things can happen to light waves when they hit a non-vacuum medium: the

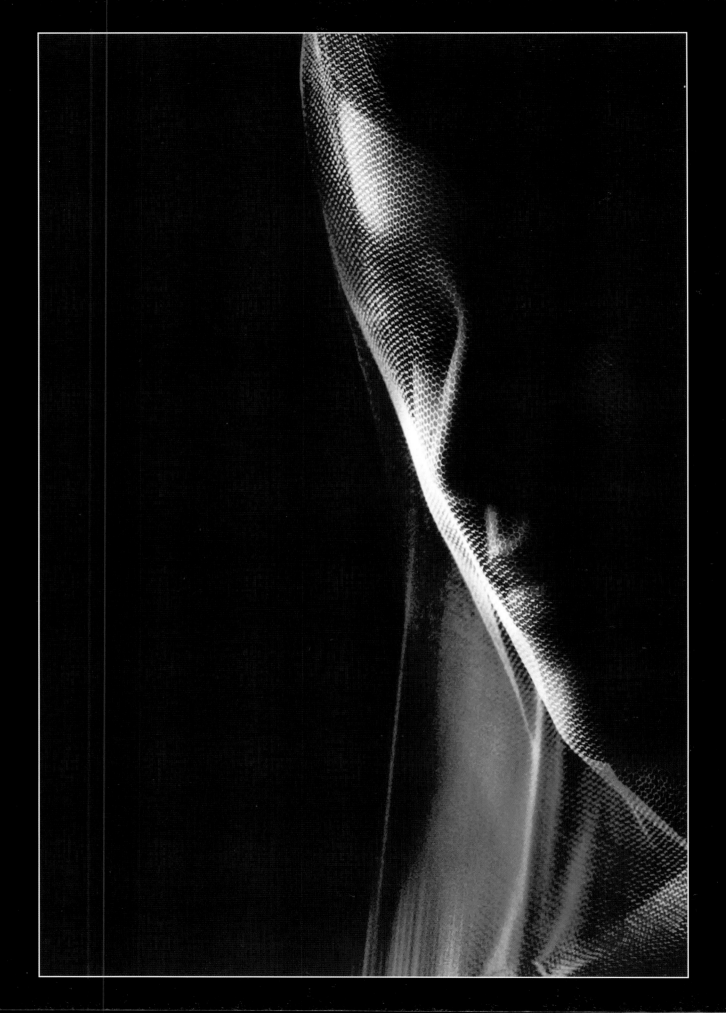

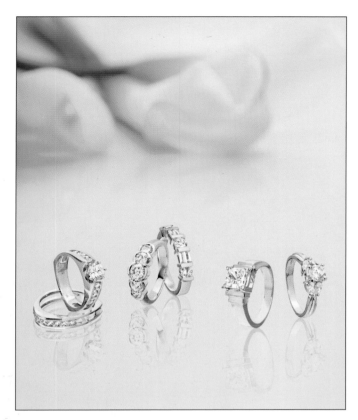

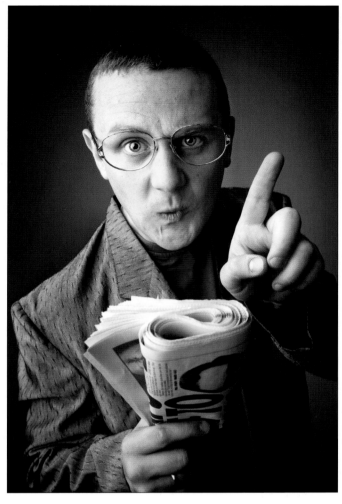

LEFT—Reflective objects like rings are extremely difficult to photograph well. Chris LaLonde created this image by first photographing the background and flower stems out of focus with a 50mm f/1.4 lens. The rings, held in place with hot glue, were photographed separately and in groups on a white background using a Kodak SLR/n digital camera and a custom-made close-up lens at f/16. Four large 600 Watt-second (Ws) strobes in softboxes were used to light the rings. One was overhead and behind the rings, two were on either side of the set, and one was behind the camera. The area was draped in with diffusion material, and white reflectors were used close to the camera so that only the lens poked through. Everything else was white. To get gradation in the rings, strips of black and gray paper were taped at the seams. This allowed non-white areas to be reflected into the metal. The camera was tethered to a Macintosh PowerBook and the image sent directly to the laptop for analysis. All images were combined in Photoshop. **RIGHT**—People with eyeglasses can be very difficult to photograph because glasses both refract and reflect light. Mark Nixon handled the technical problem quite well, using soft umbrella light from the side so that the light would not create specular highlights on the glass. He also did some extensive dodging in Photoshop to remove small problems in the glass. Because eyeglasses are a medium that reduces the amount of light being reflected through them, the area around the eyes had to be dodged and adjusted for contrast and exposure to match the rest of the subject's face. **FACING PAGE**—Large softboxes scatter light in almost every direction, diffusing the overall beam of light. Generally speaking, the larger the diffused source, the softer the light. Here, Anthony Cava used a very large softbox (5x7 feet) and a silver reflector on the shadow side to light the models for a fashion shoot for Nygård International Ltd., a fashion designer. Two strobes were used on the background from either side to get a clean white.

waves can be reflected or scattered; they can be absorbed (which usually results in the creation of heat but not light); they can be refracted (bent and passed through the material); or they can be transmitted with no effect. More than one of these results can happen at the same time with the same medium. What's important is that what will happen is predictable. This is the key to understanding lighting in a photographic environment.

Reflection. One of the characteristics of light that is important to photography has to do with reflected light waves. When light hits a reflective surface at an angle (imagine sunlight hitting a mirror), the result is totally predictable. The reflected wave will always come off the flat, reflective surface at the equal and opposite angle at which the incoming wave of light struck the surface. In simple terms, the law can be restated as this: the angle of

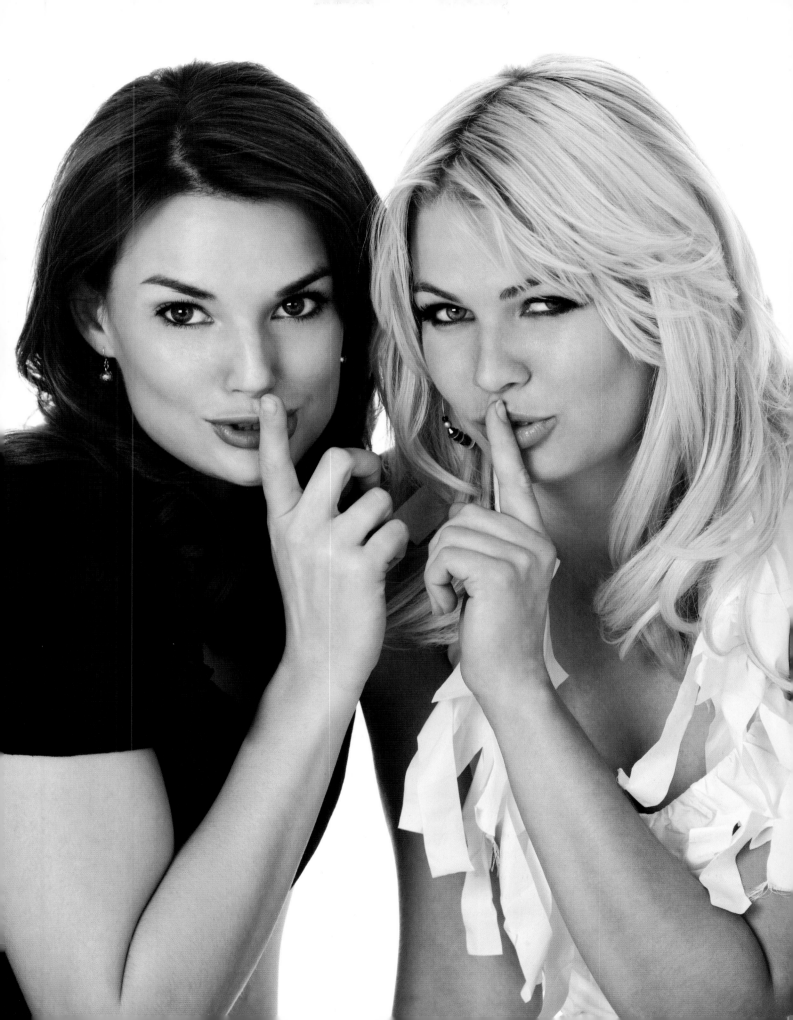

incidence is equal to the angle of reflection. Whether you are trying to eliminate the white glare of wet streets as seen through the viewfinder or to minimize a hot spot on the forehead of your bride, this simple rule will keep you pointed toward the source of the problem.

This rule also has applications in product and commercial photography. For example, when lighting a highly reflective object like silverware, knowing that the angle of incidence equals the angle of reflection tells you that direct illumination will not be the best solution. Instead, you should try to light the surface that will be reflected back onto the shiny object's surface.

Scattering. Scattering is reflection, but off a rough surface. Basically, because the surface is uneven, incom-

ing light waves get reflected at many different angles. When a photographer uses a reflector, it is essentially to distort the light in this way, reflecting it unevenly (or, put another way, so that it diffuses the light).

Translucent surfaces, such as the rip-stop nylon that is used in photographic umbrellas and softboxes, transmit some of the light and scatter some of it. This is why these

The shade of late afternoon is soft, but it also lacks sparkle. To give the light a little extra snap, photographer J.B. Sallee fired an on-camera flash that was set to output at two stops less than the daylight.

diffusion-lighting devices are always less intense than sources that emit raw, undiffused light. Some of the energy of the light waves is being discarded by scattering, and the waves that are transmitted strike the subject at

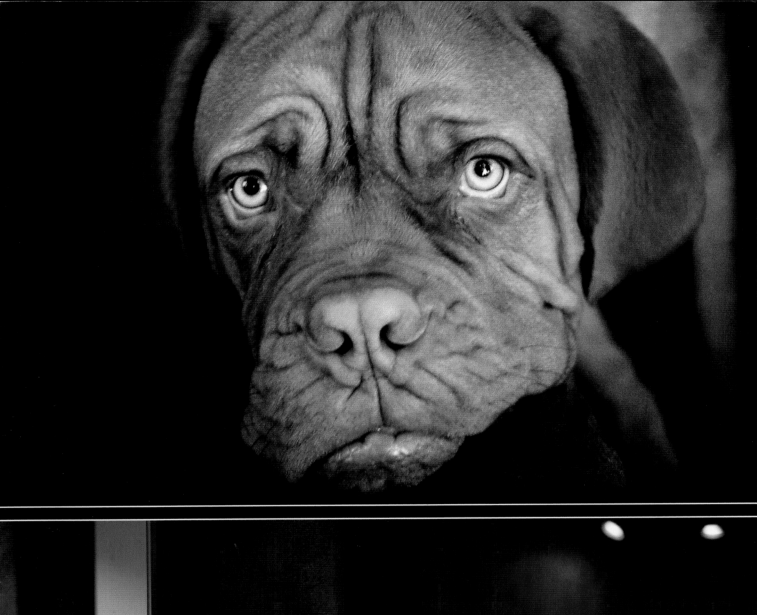
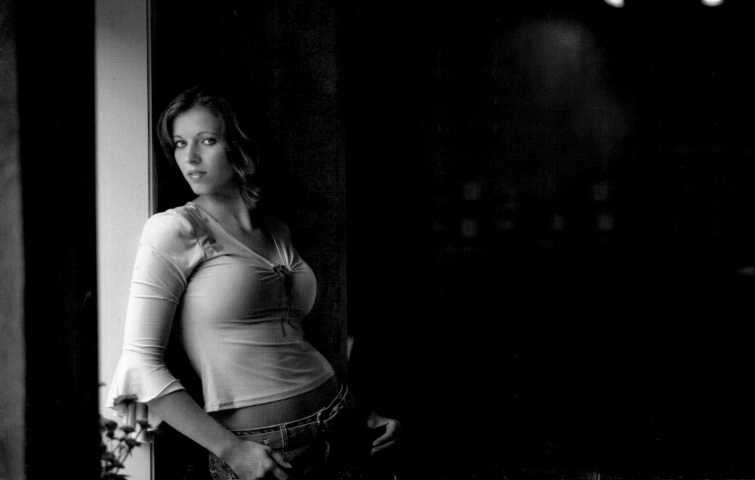

many different angles, which is the reason the light is seen as diffused.

Refraction. When light waves move from one medium to another, they may change both speed and direction. Moving from air to glass (*i.e.,* to a denser medium), for example, causes light to slow down. Light waves that strike the glass at an angle will also change direction, known as refraction. Knowing the degree to which glass elements will bend light (the refractive index) allows optical engineers to design extremely high-quality lenses, capable of focusing a high-resolution image onto a flat plane (the film or image sensor). In such complicated formulas, now almost exclusively designed by computers, the air surfaces between glass elements are just as important to the optical formula of the lens as the glass surfaces and their unique shapes.

In lighting devices, refraction is used with spotlights and spots with Fresnel lenses. These lenses, placed close to the light source, gather and focus the light into a condensed beam that is more intense and useful over a greater distance than an unfocused light of the same intensity. Spotlights are theatrical in nature, allowing the players on stage to be lit from above or the side by intense but distant lights, but they also have many applications in contemporary photography.

Absorption. When light is neither reflected nor transmitted through a medium, it is absorbed. Absorption usually results in the production of heat but not

FACING PAGE, TOP—A dog's coat, especially a dog like this with a lot of wrinkles, absorbs most of the light that strikes it. The only area of the dog's face that efficiently reflects light is his eyes. The general rule of thumb with light-absorbing subjects is to give more exposure to the image if you want to record detail in those areas. Photograph by Kersti Malvre. FACING PAGE, BOTTOM—Learning to see light takes patience and knowing what to look for. Read the main shadows to determine the direction and quality of the light. Read the catchlights (specular highlights) in the eyes and you can see the position of the light(s) relative to the person. Here Craig Kienast photographed his subject very close to a window to exploit the soft, directional light. The light falls off rapidly once it enters the large room. Note that light entering a portal, like a window or a doorway, follows the Inverse Square Law as if it were an artificial light source. RIGHT—Cherie Steinberg Coté used a Mole-Richardson 1K (1000W) light as the sole light source. The light was outfitted with a Fresnel lens, making it a spot with a narrow beam. It was positioned high and to camera left and feathered off the model's face and onto the rear wall to get the best of the light's edge effects. Feathering is necessary with direct lights (undiffused) to avoid over-lighting the subject, a condition that often results in blown-out highlights.

light. Black flock or velvet backgrounds are often used to create dense black backgrounds because they absorb all of the light striking their surfaces.

The Intensity of Light

Another characteristic of light has to do with intensity. Illumination from a light source declines considerably over distance, which is to say that the light grows weaker as the distance increases between the light source and the subject. Light from sources other than the sun (see sidebar to the left) falls off predictably in its intensity.

Put precisely, the Inverse Square Law states that the reduction or increase in illumination on a subject is inversely proportionate to the square of the change in distance from the point source of light to the subject. For example, if you double the distance from the light source to the subject, then the illumination is reduced to one quarter of its original intensity. Conversely, if you halve the distance, the light intensity doubles. This law holds true because, at a greater distance, the same amount of energy is spread over a larger area. Thus any one area will receive less light.

The Color of Light

When we look at a visible light source, it appears to be colorless or white. However, it is actually a mixture of

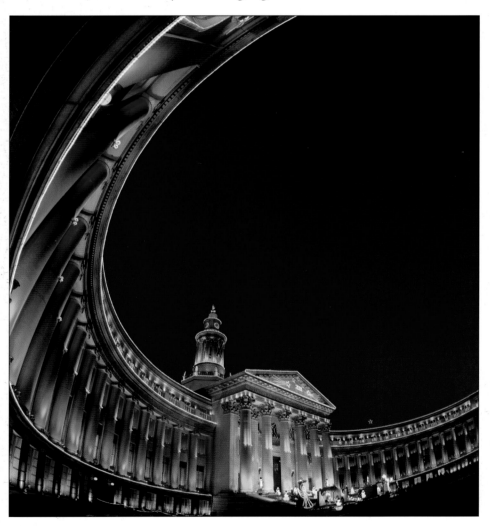

LEFT—Nancy Emmerich created this beautiful image of the Denver City Hall decked out for the Christmas holidays. She used a Mamiya RB67 and 37mm lens. The image was exposed for 30 seconds at f/16 on Fuchichrome Velvia (ISO 50) transparency film. She has not only photographed the beautifully lit building, but the light sources as well. FACING PAGE—Laser light is monochromatic, coherent, and extremely directional, so it stays intact over great distances. Jerry Ghionis talked his way into using a very elaborate laser special-effects system to photograph twelve brides in twelve different high-fashion dresses. He persuaded an Australian fashion magazine to give the laser company credit in the layout; otherwise renting such equipment would have been in excess of $4000 (Australian) per hour. Jerry selected a venue with stage lighting, and a smoke machine was used to intensify of the laser beams. The images were captured with a Canon 20D with an 85mm f/1.8 lens. He used the camera on a tripod, shooting at $^1/_{15}$ of a second at f/4–5.6. The only Photoshop that was used was color correction, selective Gaussian blur, and skin retouching.

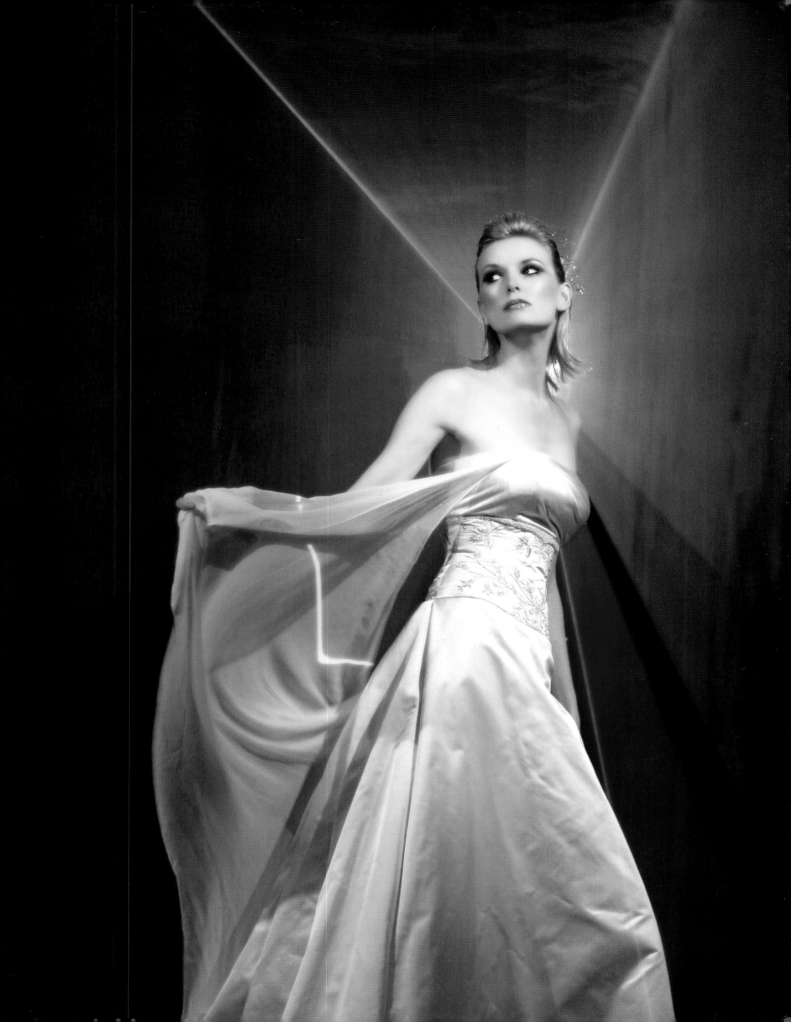

colors that the eye *perceives* as white. We know this because if you shine "white" light through a prism, you get a rainbow of colors, which are the individual components of the visible spectrum.

Yet, while the human eye perceives most light as white, few light sources are actually neutral in their color. Most have some some color cast, be it the yellow tint of household incandescent light bulbs, or the green color cast of many fluorescents. The color of light is measured in degrees Kelvin (K) and, therefore, known as the color temperature. The Kelvin scale, like the Fahrenheit and Centigrade scales, is used to measure temperature. It was devised in the 1800s by a British physicist named William Kelvin, who heated a dense block of carbon (also known as a "black body" radiator) until it began to emit light. As more heat was applied, it glowed yellow, and then white, and finally blue. The temperature at which a particular color of light was emitted is now called its color temperature. As you can see in the table below, natural and artificial light sources have many different color temperatures.

DAYLIGHT COLOR TEMPERATURES

Clear blue sky	.8000–27,000K
Misty daylight	.7200–8500K
Overcast	.6500–7200K
Direct sun, blue sky	.5700–6500K
Midday sun (9:00AM–3:00PM)	.5400–5700K
Sun at noon	.5000–5400K
Early morning or late afternoon	.4900–5600K
Sunrise or sunset	.2000–3000K

ARTIFICIAL LIGHT COLOR TEMPERATURES

Fluorescent, daylight-balanced	.6500K
Electronic flash	.6200–6800K
Fluorescent, cool white	.4300K
Photoflood	.3400K
Tungsten-halogen	.3200K
Fluorescent, warm white	.3000K
General-purpose lamps (200–500W)	.2900K
Household lamps (40–150W)	.2500–2900K
Candle flame	.2000K

FLASH AND COLOR TEMPERATURE

The light from both portable and studio flash systems also has a specific color temperature. For example, the color of the light emitted by a flash may be rated at 5500K when it is designed to imitate noon daylight. If the flash produces light that is 6000K, it will be on the cool (bluish) side. If it is rated at 4800K degrees, it is slightly warmer (more yellowish) than white light. Some professional strobe systems allow you to vary the color temperature of the lights in set degrees. This is particularly handy if you are trying to precisely match the color of a fabric or dye. It is also an effective means of "warming up" or "cooling down" a scene.

THE EXPODISC

When is comes to color balance, an accessory that many pros swear by is the ExpoDisc (www.expodisc.com), which attaches to your lens like a filter and provides perfect white balance and accurate exposure settings whether you are shooting film or digitally. The company also makes a Pro model that lets you create a warm white balance at capture. Think of this accessory as a meter for determining accurate white balance—crucial for digital imaging.

FACING PAGE, TOP—Color infrared film is highly unpredictable, both in the color it produces and the exposure time needed. Reed Young made this shot with a yellow #15 filter over the lens and the ISO set to 320. No post-production work was done with this photograph. He shot this image on a cloudy day, which he finds to be the best light for color infrared film. FACING PAGE, BOTTOM—This unusual shot was made in a tunnel after nightfall. Reed Young lit the scene with strobes. The backlight, fitted with a pink gel, was placed about forty feet into the tunnel, just out of the left side of the frame. The key light was just over the photographer's right shoulder and set so that it would not overpower the backlight. The image was recorded with a Canon EOS 10D and 28–105mm lens at $1/125$ second at f/3.5 at ISO 400. The model applied shimmer makeup to produce specular highlights across her face and neck. The poem on her face, according to Young, talks about enjoying the small things in life—but no matter what, the end is usually darker than most think. This influenced how Young lit the tunnel.

Achieving Color Balance. It is important for photographers to understand color temperature, because achieving the desired color balance in an image often requires compensating for the color of the light source. This is most commonly accomplished through film selection, filtration, or white balance selection.

Daylight films are balanced to render colors accurately when photographing under light with a color temperature of 5500K. Therefore, they produce the most accurate color during the middle of the day (9AM–3PM). Earlier and later than these hours, the color temperature dips, producing a warmer-toned image in the yellow to red range. Tungsten films, on the other hand, are balanced for a color temperature of 3200K, considerably warmer than daylight. In the film world, color balance can also be accomplished using color-compensating filters when recording an image under an off-balance light source.

In the digital world, things are much simpler; you merely adjust the white-balance setting of the camera to match the color temperature of the light. Digital SLRs have a variety of white-balance presets, such as daylight, incandescent, and fluorescent. Custom white-balance settings can also be created in-camera by taking a reading off a white card illuminated by the light source in question. When precision color balance is critical, a color-temperature meter can be used to get an exact reading of the light's color temperature in Kelvin degrees, which can then be dialed into the white-balance system of many cameras.

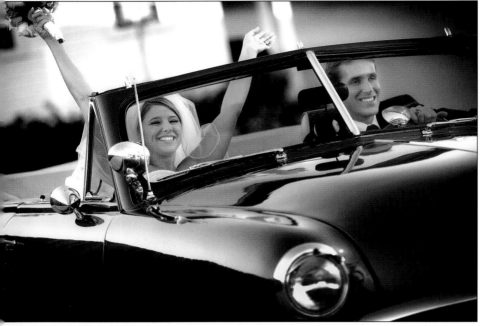

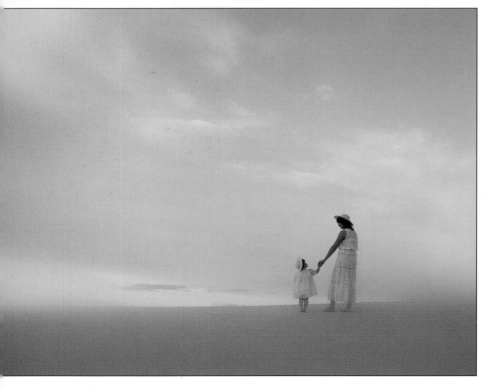

TOP—As the sun sets, it turns the sky into a massive softbox that lights everything in a diffused glow. Photographers call this "the sweet light," and it only occurs for about twenty minutes after sunset and before sunrise. This time of day isn't just great for portraits—it's also the preferred time for shooting automobiles, as the glow along the horizon creates long, beautiful highlights that reveal the curves of the vehicle. Here, DeEtte Sallee photographed the bride and groom in their vintage convertible. The image was made with the equivalent of a 265mm lens on a Nikon D2X. ABOVE—This elegant shot of mother and daughter was given an ethereal feeling by the addition of atmospheric fog in Photoshop. The original image was made at twilight with no fill-in light, so the posing had to be perfect, since the forms (rather than the surface texture and details) were what was important. The twilight rendered all parts of the image in a soft glow of light. Photograph by Gary Fagan.

2. Lighting Basics

Now that we have covered the basic concepts that control how light behaves, we can begin to explore the ways photographers put this knowledge to work when designing lighting setups. This chapter presents the basic concepts involved in photographic light-ing. We'll continue to explore more specialized techniques in subsequent chapters.

Two Primary Lights

The lights that create virtually all lighting patterns and effects are the key light and the fill light. Even though many different lights may be used in any given photo-graph, the effect should be the same: that of a key light and a fill light. As noted previously, our human percep-tion is so accustomed to the sun providing our single source of light, that we are happiest when artificial light-ing arrays mimic that effect.

Key Light. The key light is what creates form, pro-ducing the interplay of highlight and shadow. Where you place the key light will determine how the subject is ren-dered. You can create smoothness on the subject's sur-face by placing the light near the camera and close to the camera/subject axis; you can emphasize texture by skim-ming the light across the subject from the side. The key light is the primary tool of the photographic artist, al-lowing you to paint texture and shadow where you want it by virtue of its placement relative to the subject.

Stacy Bratton, a highly acclaimed children's photographer, uses a large softbox as a key light, then adds fill light by bouncing strobe into large white cards above the set (which she calls her "up lights"). The resul-ing illumination blankets the set with ultrasoft lighting, producing a very low lighting ratio of 1.5:1 to 2:1 on the subject.

LEFT—In this beautiful glamour portrait by Tim Schooler, the key light comes from behind the subject a little to camera right. You can determine this because the right side of her face and nose are highlighted. The fill light, which is close to the same intensity as the key light, comes from camera left and fills the shadow side of the model's face. Additional fill is achieved by the white crepe material, which is reflecting light everywhere within the scene. You will notice that even though the lights are fairly even in intensity, the key light still provides direction and bias.
BELOW—In the studio, as in nature, the key light provides the emphasis of the lighting setup. Sometimes the only light used is a key light, as is the case in this photo by Barbara Bauer, where the key light was a shoot-through type umbrella with no fill light.

Fill Light. The light source that makes the "shadow side" of things visible is called the fill light. The fill light is defined as a secondary light source because it does not create visible shadows. Photographers have found that the best way to achieve this shadow-filling effect is to place the fill light as close as possible to the camera–subject axis. All lights, no matter where they are or how big, create shadows. But by placing the fill light as near the camera as possible, all the shadows that are created by that light are cast behind the subject and are therefore less visible to the camera. Just as the key light defines the lighting, the fill light augments it, controlling the intensity of the shadows created by the key light.

Creating fill light with a reflector is popular in all forms of photography. The reflectors available today are capable of reflecting any percentage of light back on to the subject—from close to 100 percent reflectance with various mirrored or Mylar-covered reflectors, to a very small percentage of light with other types. Reflectors can also be adjusted almost infinitely just by finessing the angle at which they are reflecting the fill-in light.

Size of the Light

The size of the light source also affects the results you will produce. Small light sources create tiny shadows across a surface; larger light sources, on the other hand, tend to automatically fill in the shadows because of the wraparound quality of the light.

Smaller light sources produce crisper shadows with a sharper transition from highlight to shadow across the subject. If you want texture, which often equates to drama (especially when minimal fill-in illumination is employed in the image) use a small light source.

Larger light sources produce softer shadows with a more even gradation from highlight to shadow. If you want smoothness or softness, use a large light source. The advantage to using larger light sources is that they tend to be more forgiving and easier to use. The disadvantage is that they reveal less texture.

The effective size of a light source is determined both by the physical size of the source itself and its distance to the subject. Man-made light sources are physically very small, but they can be made larger by placing them in a light-modifying device like a softbox or umbrella. The light modifier lessens the intensity of the light, but makes it larger and more diffuse in nature. Placing the light source closer to the subject will also make it effectively larger, yielding softer effects. Conversely, distancing the source from the subject will produce crisper, more dramatic lighting.

Lighting Ratios

A lighting ratio is a numeric expression of the difference in intensity between the shadow and highlight side of the

THE THREE-DIMENSIONAL ILLUSION

The human face is sculpted and round; it is the job of the portrait, fashion, or editorial photographer to reveal these contours. This is done primarily with highlights and shadows. Highlights are areas that are illuminated by a light source; shadows are areas that are not. The interplay of highlight and shadow creates the illusion of roundness and shows form. Just as a sculptor models the clay to create the illusion of depth, so light models the shape of the face to give it depth and dimension. A good photographer, through accurate control of lighting, can reliably create the illusion of a third dimension in the two-dimensional medium of photography.

USING HOT LIGHTS

Using 1000W (1K) hot lights requires some care and safety. A standard 20-amp household circuit provides 2000W of power at maximum capacity, so if two 1K lights are plugged in, you are using the maximum amount of power. If, anywhere in the building, there is another device running on that circuit, you will be drawing more power than is possible and the circuit breaker will engage—meaning you will lose power to the lights and anything else on that circuit. This is why photographers who use hot lights frequently carry lots of long extension cords so that they can power the lights from different outlets and distribute the load evenly over the electrical system.

Another concern is that hot lights are literally *hot*. The bulbs, lenses, casings, and sometimes even the stands themselves, get quite hot. For that reason, using heavy leather gloves is recommended when working with hot lights. You should also make sure the lights are turned off at the switch before plugging them in. Additionally, you should "sandbag" any tall light stands and all boom stands to make them more stable.

If you have to change a blown lamp (bulb), turn off the power switch and unplug the light. While wearing your leather gloves, open the face of the light after it has cooled. This will protect you from burns, but it also protects the new bulb you will be inserting. Oils from your fingers can be deposited on the bulb surface if you handle it without gloves, which can cause the glass to explode. This is particularly true for quartz-halogen bulbs. Carefully remove the lamp from its housing and take the new lamp out of its box using the foam padding that comes surrounding the bulb. This is perfect for handling the light and inserting it into the lamp fixture.

The beauty of using hot lights is that you can always see what you're going to get photographically. The dangers, however, are real and should be factored into any lighting setup.

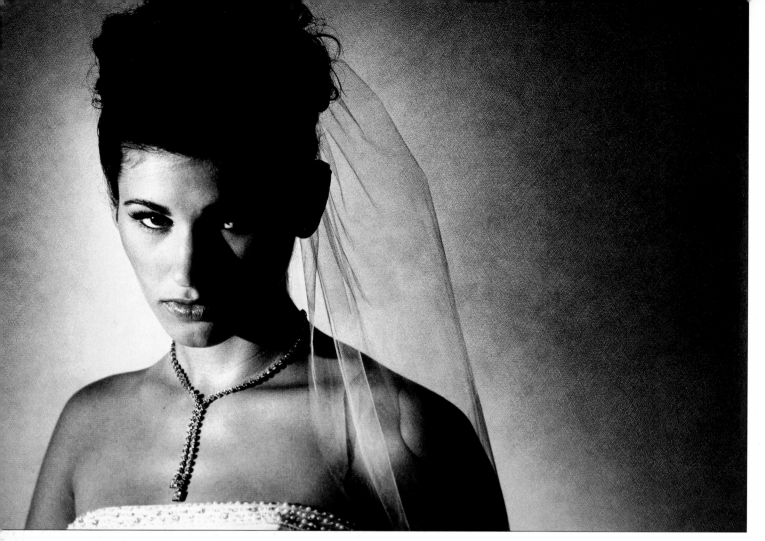

A hot light was used to produce this very dramatic portrait with a high lighting ratio. Cherie Steinberg Coté positioned the light above and close to her model so that it produced the traditional Rembrandt triangle on the shadow side of her face. No fill source was used.

face in portraiture. A ratio of 3:1, for example, means that the highlight side of the face has three units of light falling on it, while the shadow side has only one unit of light on it. Ratios are useful because they describe how much local contrast there will be in the portrait. They do not, however, reflect the overall contrast of the scene.

Since lighting ratios tell you the difference in intensity between the key light and the fill light, the ratio is an indication of how much shadow detail you will have in the final portrait. Since the fill light controls the degree to which the shadows are illuminated, it is important to keep the lighting ratio fairly constant. A desirable ratio indoors or out is 3:1. This ratio guarantees both highlight and shadow detail and is useful in a wide variety of situations.

Determining Lighting Ratios. There is considerable debate and confusion over the calculation of lighting ra-

tios. This is principally because you have two systems at work, one arithmetical and one logarithmic. F-stops are in themselves a ratio between the size of the lens aperture and the focal length of the lens, which is why they are expressed as "f/2.8," for example. The difference between one f-stop and the next full f-stop is either half the light or double the light. For example f/8 lets in twice as much light through a lens as f/11 and half as much light as f/5.6. However, when we talk about lighting ratios, each full stop is equal to two units of light, each half stop is equal to one unit of light, and each quarter stop is equivalent to half a unit of light. This is, by necessity, a suspension of disbelief—but it makes the lighting-ratio system explainable and repeatable.

In lighting of all types, from portraits made in diffused sunlight to editorial portraits made in the studio, the fill light is always calculated as one unit of light, be-

cause it strikes both the highlight and shadow sides of the face. The amount of light from the key light, which strikes only the highlight side of the face, is added to that number. For example, imagine you are photographing a small family group and the key light is one stop (two units) greater than the fill light (one unit). The one unit of the fill is added to the two units of the key light, yielding a 3:1 ratio; three units of light fall on the highlight sides of the face, while only one unit falls on the shadow sides.

Lighting Ratios and Their Unique Personalities. A 2:1 ratio is the lowest lighting ratio you should employ. It reveals only minimal roundness in the face and is most desirable for high-key effects. High-key portraits are those with low lighting ratios, light tones, and usually a light or white background (see the sidebar on page 28). In a 2:1 lighting ratio, the key and fill-light sources are the same intensity (one unit of light falls on the shadow and highlight sides of the face from the fill light, while one unit of light falls on the highlight side of the

1961 was created by Reed Young as a commercial assignment at Brooks Institute of Photography. He wanted to recreate the '60s and found this building, which is actually an art gallery. He had to build platforms for the models out of 2x4s with a Mylar deck surface. He lined the non-glass surfaces of the display window with seamless background paper. Reed used three Profoto 2400Ws strobes in 3x4-foot softboxes, plus a Q-flash that was positioned thirty feet in the air to provide a little "street lighting." One of the softboxes was used outside to skim the building exterior, providing texture without lighting the glass. The other two softboxes were used above the models out of view of the camera with no fill. The lights were fired by using Pocket Wizards to sync the strobes. The models were told to pose like mannequins. The final effect was to wet the sidewalk, which further enhances the mood. Because of the single overhead softbox, the lighting ratio on the models is fairly strong—about 4:1. The lighting ratio on the exterior is a lot lower—about 3:1.

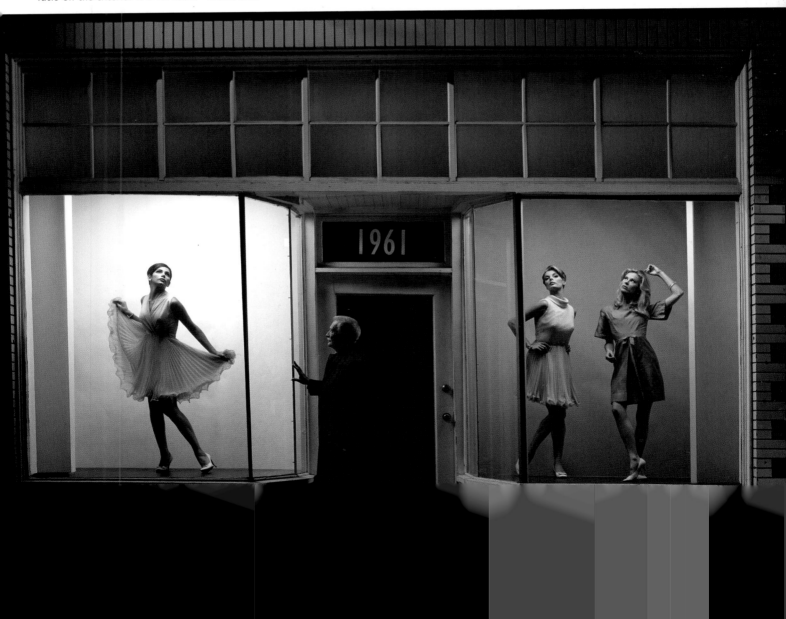

HIGH-KEY LIGHTING

There are a number of ways to produce high-key portrait lighting, but all require that you overlight your background by 1½ to 2 stops. For instance, if the main subject lighting is set to f/8, the background lights should be set at f/11 to f/16. Sometimes photographers use two undiffused light sources in reflectors at 45-degree angles to the background, feathering the lights (angling them) so that they overlap and spread light evenly across the background. Other setups call for the background lights to be bounced off the ceiling onto the background. In either case, they should be brighter than the frontal lighting so that the background goes pure white. Because light is being reflected off a white background back toward the lens, it is a good idea to use a lens shade to try to minimize flare, which often occurs in high-key setups.

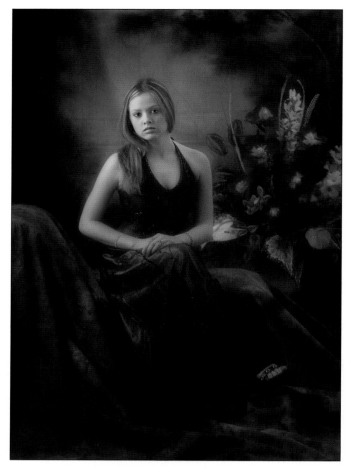

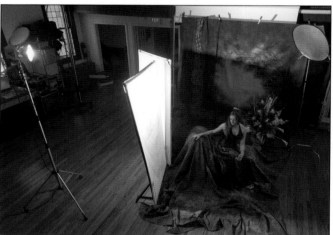

In this series of illustrations, Claude Jodoin shows how to create a low-key image with one light and no main fill. The single Alien Bees strobe was fired through two scrims to produce a soft wraparound split light. A silver reflector kicks a little light back onto the model's hair for dimension. Some mild diffusion was added in Photoshop for a more romantic feeling. Even though the image is low-key, the lighting ratio is no more than 2:1. The low-key feeling is achieved by biasing exposure toward the shadows and by using dark tones throughout.

face from the key light—1+1:1=2:1). A 2:1 ratio will widen a narrow face and provide a flat rendering that lacks dimension.

A 3:1 lighting ratio is produced when the key light is one stop greater in intensity than the fill light (one unit of light falls on both sides of the face from the fill light, and two units of light fall on the highlight side of the face from the key light—2+1:1=3:1). This ratio is the most preferred for color and black & white because it will yield an exposure with excellent shadow and highlight detail. It shows good roundness in the face and is ideal for rendering average-shaped faces.

A 4:1 ratio (the key light is 1½ stops greater in intensity than the fill light—2+1+1:1=4:1) is used when the photographer wants a slimming or dramatic effect. In a 4:1 ratio, the shadow side of the face loses its slight glow and the accent of the portrait becomes the highlights. Ratios of 4:1 and higher are considered appropriate low-key portraits. Low-key portraits are characterized by a higher lighting ratio, dark tones, and usually a dark background.

A 5:1 ratio (the key light is two stops greater than the fill light—2+2+1:1=5:1) is considered almost a high-contrast rendition. It is ideal for adding a dramatic effect to your subject and is often used in character studies. Shadow detail is minimal with ratios of 5:1 and higher. As a result, they are not recommended unless your only concern is highlight detail.

Most seasoned photographers have come to recognize the very subtle differences between lighting ratios, so fractional ratios (produced by reducing or increasing the fill light amount in quarter-stop increments) are also

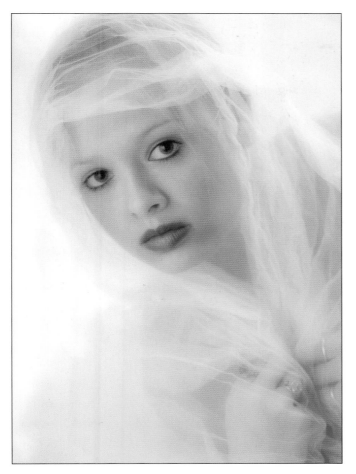

Claude again illustrates a one-light portrait using backlighting through a scrim and another scrim used as a frontal reflector. The same low-powered Alien Bees strobe was aimed down on the model to produce an overhead backlight. The exposure was biased towards the highlights to create a high-key look. In all three of these exposures, made with a FujiFilm FinePix S2, a custom white-balance reading was made first with an ExpoDisc. According to Claude, who shoots in Fine JPEG mode, he never has to color balance a file in Photoshop, insisting that he "gets it right" in the camera.

This is high-key image power. As you can see from the standing pose, the strobe was fired through a scrim and a standing second scrim and white floor covering acted as fill. In this image you can really see how clean the whites are in Claude's brand of digital portraiture—a characteristic he proudly attributes to the ExpoDisc and good exposures.

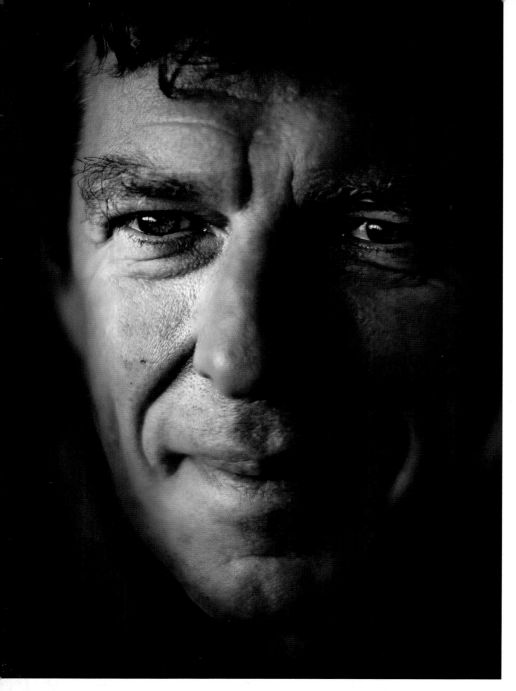

Marcus Bell used classic low-key lighting to create this intense portrait for his *Faces of Queensland* book project. Marcus helped the ratio by lowering the exposure settings in RAW mode and by later vignetting the image in Photoshop. The light is window light but the subject was a distance from the window, making the light more contrasty.

render subject tones at a value of 18-percent gray. This is rather dark even for a well-suntanned or dark-skinned individual. So, when using the in-camera meter, you should meter off an 18-percent gray card held in front of the subject—one that is large enough to fill most of the frame. (If using a hand-held reflected-light meter, do the same thing; take a reading from an 18-percent gray card.)

A better type of meter for portraiture is the handheld incident-light meter. This does not measure the reflectance of the subject; instead, it measures the amount of light falling on the scene. To use this type of meter, simply stand where you want your subject to be, point the hemisphere of the meter directly at the camera lens, and take a reading. Be sure that the meter is held in exactly the same light that your subject will be in. This type of meter yields extremely consistent results and is less likely to be influenced by highly reflective or light-absorbing surfaces. (A good rule of thumb when setting your lights is to point the meter at the light source if only one light source is being measured; if multiple lights are being metered, point the dome of the meter at the camera lens.)

A handheld incident flashmeter is useful for determining lighting ratios—and crucial when mixing flash and daylight. Flashmeters are also invaluable when using multiple strobes and when trying to determine the overall evenness of lighting in a large-size room. Flashmeters are ambient incident-light meters, meaning that they measure the light falling on them and not light reflected from a source or object, as the in-camera meter does.

used. For instance, a photographer might recognize that with a given face, a 2:1 ratio does not provide enough roundness and a 3:1 ratio produces too dramatic a rendering, thus he or she would strive for something in between—a 2.5:1 ratio.

Metering

Exposure is critical to producing fine portraits, so it is essential to meter the scene properly. Using the in-camera light meter may not always give you consistent and accurate results. In-camera meters measure reflected light and are designed to suggest an exposure setting that will

3. Studio Lighting

While there are many types of high-intensity lights designed for photography, most professional photographers choose to work with strobes—electronic studio flashes. Strobes have several advantages over other types of lighting: they are cool working, portable, and run on household current. They also use self-contained modeling lights that are usually variable (dimmable) quartz-halogen bulbs that mimic the light of the surrounding flash tube, helping you to visually gauge the effect you are creating before shooting.

Studio Strobe Systems

Studio strobes come in two types: monolights and power-pack kits. In either case, the strobes must be triggered by the camera to fire at the instant the shutter curtain is open. This is most simply accomplished with a sync cord that runs from the camera's PC connection to one of the monolights or to the power pack, depending on the system you choose.

Monolights. Monolights are self-contained. These units contain light triggers to fire the strobe when they

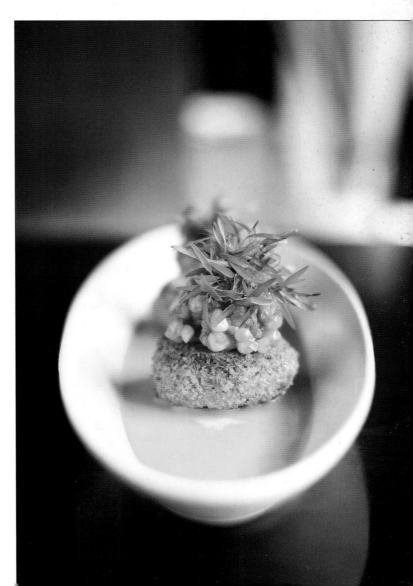

This photo of crab cakes is from a series of shots Chris LaLonde did for Costco to be used in their *Costco Connections* magazine. The image was Shot with a Nikon D1X and 50mm f/1.4 lens at ISO 160 at an exposure of ¹/₁₀ second at f/2. LaLonde used a large bank of windows with scrims taped to the inside of the windows to soften the light. A combination of reflectors and small beauty mirrors on adjustable stands were then used to bounce strong light back onto the subject. Food, in order to appear tasty, requires specular highlights on its surfaces; this is a function of the small mirrors.

sense the light of another strobe, so they can be used very far apart and are ideal for location lighting or large rooms. Simply plug one into a household AC socket and you're ready to go.

Power-Pack Systems. Power-pack systems accept multiple strobe heads—up to four individual strobe heads can usually be plugged into a single, moderately priced power pack. This type of system is most often used in studios, since you cannot move the lights more than about twenty-five feet from the power pack. Power-pack outlets are usually divided into two channels with variable settings, providing symmetrical or asymmetrical output distributed between one, two, three, or four flash heads.

What to Look For

Things to look for in a studio strobe system are:

Power. Strobe systems are rated in Watt-seconds (Ws); the more Watt-seconds, the more light output. Keep in mind that, when considering the total output rating of the power pack, you must divide the total Watt-seconds by the number of flash heads to be used.

Flash Duration. Look for short flash durations, ranging from $\frac{1}{800}$ to about $\frac{1}{12,000}$ second. The longer the flash duration, the less action-stopping ability the system has and the more likely it becomes that exposures may be influenced by existing light.

Recycle Times. Fast recycling times are desirable, ranging from 2 seconds down to less than $\frac{1}{4}$ second. The faster the recycling time, the faster you can make consecutive full-power exposures.

Modeling Lights. Proportional modeling lights are a necessity, so that each light can be made to closely resemble the output of the individual flash tube. Without accurate modeling lights, precise lighting effects are impossible.

Color Temperature. Consistent color-temperature output is a must-have feature. Some systems' color-

temperature output will vary depending on the recycle rate, causing uneven exposures and color and, therefore, color-correction problems. Variable color-temperature settings are available on some systems, which can be adjusted in 50K intervals for warmer or cooler output.

Fan-Cooled Generator. Power-pack systems have a tendency to overheat and will often require an internal fan to cool the electronics.

Multi-Voltage Capability. This feature allows the strobe system to be used in different countries with different power systems. Often, this is an automatic, self-seeking function that the photographer never even has to worry about.

Computer Control. Some of the recently introduced systems offer a computer interface so that settings can be changed from a laptop or PDA—an invaluable feature for remote applications.

Open-Flash Function. The open flash control fires the flash manually in the predetermined configuration. It is ideal for open-shutter multiple pops.

Heads and Accessories. The wider the range of flash heads, accessories and light modifiers available for any given system, the more useful the system.

Types of Studio Strobes and Accessories

Here are some variations in strobes and the accessories used to modify the quality and quantity of light output.

Barebulb. When the reflector is removed from the flash head, you have a barebulb light source. The light scatters in every direction—360 degrees. Removing the reflector has advantages if you have to place a light in a confined area. Some photographers use a barebulb flash as a background light for a portrait setting, positioning the light on a small floor stand directly behind the subject. Barebulb heads are used inside softboxes, light boxes, and strip lights for the maximum light spray inside the diffusing device.

Barn Doors. These are black, metallic, adjustable flaps that can be opened or closed to control the width of the beam of the light. Barn doors ensure that you light only the parts of the scene you want lit. They also keep stray light off the camera lens, helping to prevent lens flare.

Diffusers. A diffuser is nothing more than frosted plastic or acetate in a frame or screen that mounts to the

THE CASE FOR MONOLIGHTS
Master photographer and digital guru, Claude Jodoin says, "When I use flash, I prefer the precision and repeatability of monolights with fast recycle times, such as the Alien Bees 400- and 800-Ws units. Running those at $\frac{1}{8}$ or $\frac{1}{4}$ power for apertures around f/5.6 (for zooms), lets the camera capture images as fast as a model can move. This eliminates underexposed images caused by slow recycling flash heads. Since the noise maps of modern digital SLRs are not visible in a print between ISO 100–400, I usually increase that instead of flash power to maintain the highest shooting speed for a given lens aperture.

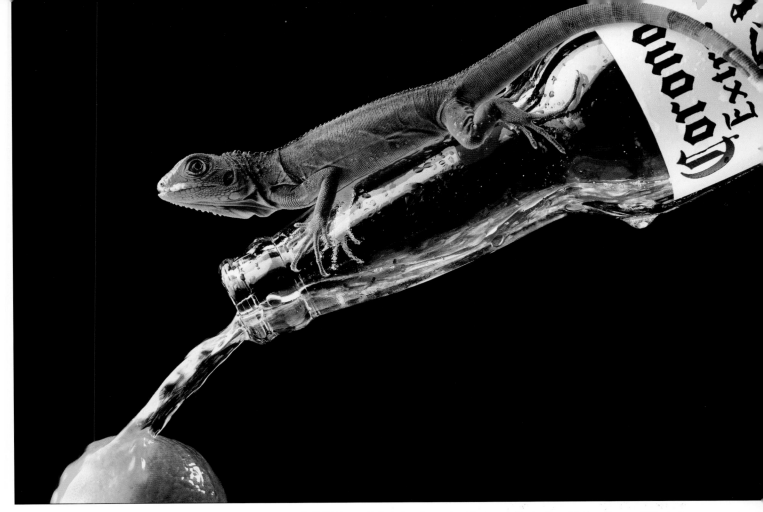

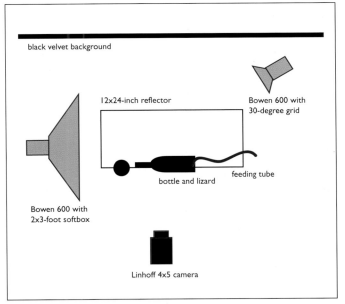

black velvet background

12x24-inch reflector

Bowen 600 with
30-degree grid

bottle and lizard

feeding tube

Bowen 600 with
2x3-foot softbox

Linhoff 4x5 camera

Chris LaLonde made this image in studio with two Bowen 600 strobes and a white cardboard reflector. He shot against a black velvet backdrop in order to get a clean, pure black. The main light, a 2x3-foot softbox, was positioned over and to the left of the iguana, ensuring the highlight would be retained over the entire length of the bottle. The reflector was positioned parallel to the bottle and directly underneath it. LaLonde added a kicker, a Bowen 600 with grid, from the back right to give some separation and highlights. A Linhof 4x5 view camera with a 210mm Rodenstock lens and Kodak E100 film were used at an exposure of $1/500$ second at f/8. The bottle was mounted on a studio stand and the bottom was removed so that beer could continually run through it. According to Chris, "The iguana was placed on the bottle and held in place with crazy glue—just kidding; gravity did the job. I was simply very patient and had a container with padding positioned underneath in case the lizard fell—and, believe me, it did. Between refills and the model falling off, it took approximately three hours to get ten sheets of film exposed. No digital was used in post-production; everything was done in the camera."

lamp's metal reflector, usually on the perimeter of the reflector. A diffuser turns a parabolic-equipped light into a flood light with a broader, more diffused light pattern. When using a diffuser over a light, make sure there is sufficient room between the diffuser and the reflector to allow heat to escape (this is more important with hot lights than with strobes). The light should also have barn doors attached. As with all lights, they can be "feathered" by aiming the core of light away from the subject and just using the edge of the beam of light.

LIGHTING FOOD WITH CONTINUOUS LIGHT SOURCES

Vincent Isola is a commercial photographer who likes the challenge of photographing food. While he prefers strobe for most commercial assignments, he prefers continuous light sources for food because, as he says, "Images where the exposure is built up over ½ to 3 seconds have a much different mood and softer feeling to them than a shot done with a strobe firing at ¹⁄₂₅₀ second or greater, instantly exposing and freezing the image." Using continuous light sources also gives the photographer the advantage of seeing the actual contrast of the scene rather than an approximation like strobes give you.

He recently switched over to the Westcott SpiderLite TD5, which is supplied with both daylight-fluorescent and tungsten tubes. It can also be fitted with Edison screw-mount AC-powered strobes. The advantage of using fluorescent is that it puts out almost no heat, so the light can be used very close to the food. The SpiderLite TD5 contains five coiled fluorescent tubes in a compact housing which fits nicely into a Westcott 24x32-inch softbox, which Vin used for his food shots shown here.

The SpiderLite TD5 contains five coiled fluorescent tubes in a compact housing that fits nicely into a 24x32-inch softbox. This is what Vin used for his food shots shown here. The SpiderLite can be configured with either AC-powered strobes, tungsten tubes, or the fluorescent coils.

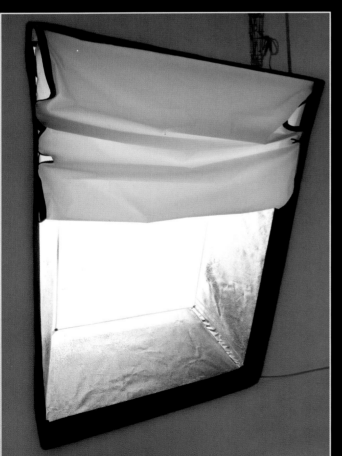

A front and back view of the light table shows how the SpiderLite TD5s were used. Included is a detail view of the softbox that demonstrates how Vinnie created soft, even lighting on the table by doubling the diffusion fabric closest to the box and allowing the strongest part of the light to travel the longest distance.

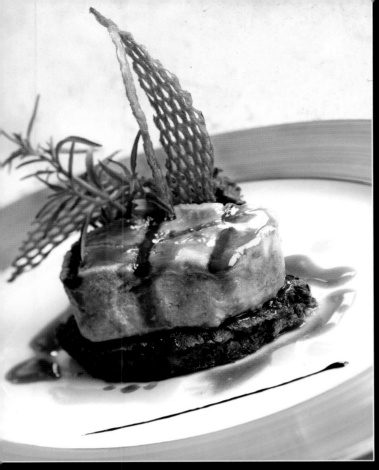

ABOVE—The SpiderLite was placed at a 45-degree angle behind and to the right of the plates. It was about 12 inches from the plates and about 12 inches above them. A white card was placed at a 45-degree angle in front of the plates and moved in and out to pick up the ratio Vin wanted. He used an opaque finger on a C-stand to block some of the light, keeping it from burning out the potato on the pork. TOP RIGHT—Vin placed the light behind and to the right of the dish at a 45-degree angle. Again, it was approximately 12 inches from the dish and about 12 inches above it. He placed a black 12x20-inch gobo on a C-stand approximately 45 degrees to the front left of the subject and moved it back and forth until he got the contrast he wanted. LEFT—Vin set the SpiderLite at a 90 degree angle to the right of the fruit cups, then backed the light off to about 24 inches and removed the front diffuser for a sharper, more contrasty light source. He moved the light in and out and up and down until he picked up the specular highlights he wanted on the berries. He also added a 12x20-inch Mylar reflector on a C-stand above the set, placed at a 90-degree angle to the front left, to pick up the contrast and highlights he wanted.

Three separate controls allow you to run fluorescent and tungsten lamps together with no shift in color temperature.

In order to bring down some of the hot spots in the scene closest to the light source, Isola uses opaque dots and fingers (miniature gobos) on C-stands. He'll also sometimes use a Mylar reflector on a C-stand above the set and to the side to pick up the contrast a bit and to add selective highlights.

Flats. Flats are large, white opaque reflectors that are portable (usually on rollers or casters). Once they are wheeled into position, lights can be bounced into them like a temporary wall.

Gobos. Sometimes, because of the nature of the lighting, it is difficult to keep unflattering light off of certain parts of the portrait. For instance, hands that receive too much light can gain too much dominance in the photograph. A good solution is to use a device called a gobo or flag, which is a light blocking card (usually black) that can be attached to a boom-type light stand or C stand, or held by an assistant. When placed in the path of a diffused light source, the light will wrap around the flag, creating a very subtle light-blocking effect. The less diffused the light source, the more pronounced the effect of the gobo will be.

In the field, these panels are often used to block overhead light in situations where no natural obstruction exists. This minimizes darkness under the eyes and, in effect, lowers the angle of the key light so that it is more of a sidelight. Gobos are also used to create a shadow when the the key-light source is too large, with no natural obstruction to one side or the other of the subject.

Grid Spots. Grid spots are honeycomb metal grids that snap onto the perimeter of the light housing. They come usually in 10-, 30-, and 45-degree versions, with the 10-degree grid providing the narrowest beam of light. Each comb in the honeycomb grid prevents the light from spreading out. Grid spots produce a narrow core of light with a diffused edge that falls off quickly to black. Because the light is collimated, there is very little spill with a grid spot. Grid spots provide a great amount of control because they allow you to place light in a specific and relatively small area. This makes them ideal for portraits where a dramatic one-light effect is desired. The light naturally feathers at its edge providing a beautiful transition from highlight to shadow. If the grid spot is the only frontal light used in a studio setting, the light will fall off to black, for a very dramatic effect.

Mirrors. Mirrors are used to bounce light into a shadow area or to provide a reflected key light. Mirrors reflect a high percentage of the light that strikes them, so they can be used outdoors to channel backlight into a key light. On a tabletop setup, small mirrors the size of matchbooks are sometimes used to kick light into a hard-to-light area.

Reflectors. A reflector is any surface used to bounce light into shadow areas. A wide variety of reflectors are available commercially, including the kind that are collapsible and store in a small pouch. The surface of reflectors can be white, translucent, silver foil, black (for subtractive lighting effects), or gold foil. The silver- and gold-foil surfaces provide more light than matte white or translucent surfaces. Gold-surfaced reflectors are also ideal for shade, where a warm-tone fill is desirable.

When using a reflector, place it slightly in front of the subject's face, being careful not to have the reflector beside the face, where it may resemble a secondary light source coming from the opposite direction of the key light. Properly placed, the reflector picks up some of the key light and wraps it around onto the shadow side of the face, opening up detail even in the deepest shadows.

Parabolic Reflectors. Photographic lights accept different sizes of parabolic reflectors (also called pans because of their shape), which mount to the perimeter of the light housing. Without a reflector, the bare bulb would scatter light everywhere, making it less efficient and difficult to control. In the old days, everything was lit with polished-silver metal parabolics because of the light intensity needed to capture an image on very slow film. This was obviously before strobes. The advantage of learning to light with parabolics is that you had to see and control light more efficiently than with diffused light sources, which are infinitely more forgiving.

Parabolics create a light pattern that is brighter in the center with light gradually falling off in intensity toward

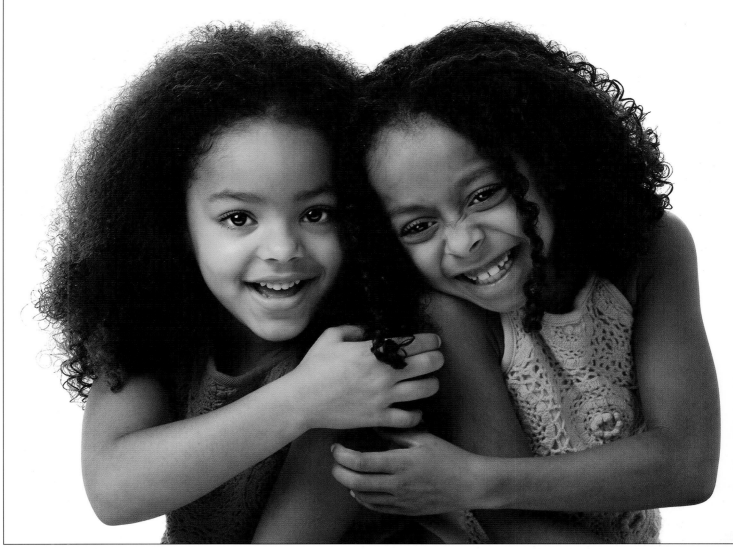

Deborah Lynn Ferro used umbrellas to light the little girls and the background, achieving a clean white with no flare. The background light was about two stops hotter than the frontal light.

the edges. The penumbra is the soft edge of the circular light pattern and is the area of primary concern to the portrait photographer. The center of the light pattern, the umbra, is hot and unforgiving and produces highlights without detail on the face. Feathering the light (adjusting the light to use the soft edge of the light pattern) will help achieve even illumination across the facial plane with soft specular highlights.

Today, some pan reflectors are polished, while some use a brushed matte surface to diffuse the light beam. Some have facets that gather and focus the light. Photographers rarely use undiffused pan reflectors any more, but for beautiful specular light with a highly functional feathered edge, nothing beats the polished models.

The smallest of these reflectors is usually the five-inch standard reflector, which is good for protecting the flash tube and modeling light from damage. It also makes the light more compact for traveling.

With the wide-angle reflector attached, light is reflected out in a wide pattern. This reflector is often used to focus the light onto the full surface of an umbrella and to shoot into flats or scrims. The wider spread of light also makes this modifier ideal for bouncing light off ceilings and walls—it is controllable and efficient, with minimal light loss. The resulting bounced light is soft, and the quality can be controlled by changing the distance from the flash head to the reflector, wall, or ceiling.

Scrims. Scrims are translucent diffusers. Light is directed through the material of the scrim to diffuse the light. In the movie business, huge scrims are suspended like sails on adjustable flats or frames and positioned between the sun (or a bank of lights) and the actors, dif-

fusing the light over the entire area. A scrim works the same way a diffuser in a softbox works, scattering the light that shines through it.

Legendary photographer Monte Zucker perfected a system of using large scrims—3x6 feet and larger. With the sun as a backlight, he had two assistants hold the translucent light panel above and behind the subject so that the backlighting was diffused. He paired this with a reflector placed close in front of the subject to bounce the diffused backlight onto the subject or subjects. The effect is very much like an oversized softbox used close to the subject for shadowless lighting.

Scrims can also be used in window frames to soften sunlight. Tucked inside the window frame, the scrim is invisible from the camera position.

Snoots. Snoots are attachments that snap to the light housing and resemble a top hat. Snoots narrow the beam of light into a very thin core. They are ideal for small edge lights used from behind the subject.

Softboxes. A softbox is like a tent housing for one or more undiffused strobe heads. Often, fiberglass rods provide the rigid support of the softbox housing. The frontal surface is translucent nylon, usually a double thickness. The sides are black on the outside and white on the inside to gather and diffuse more light. Softboxes come in many sizes and shapes. Although most are square or rectangular, there are also a few round or octagonal ones. The size ranges from 12-inches square all the way up to 5x7 feet. Softboxes are the ideal means of putting a lot of diffused light in a controlled area, and provide much more precise control over the light than umbrellas, which lose much of their light intensity to scatter. Some softboxes accept multiple strobe heads for additional lighting power and intensity.

Strip Light. A strip light is a long skinny softbox. Strip lights are used as background and hair lights in portraiture, as well as edge lights for contouring in tabletop photography. Sometimes they can be used as odd-shaped

Vicki Taufer likes large softboxes and soft light for her young subjects. Here, the little chef was lit by two softboxes at close to a 45-degree angle to the subject. No fill was used, producing abrupt light falloff on the shadow side of her face. There was so much light bouncing around the set that there really wasn't any need for additional fill light. The light ratio was still about 3:1.

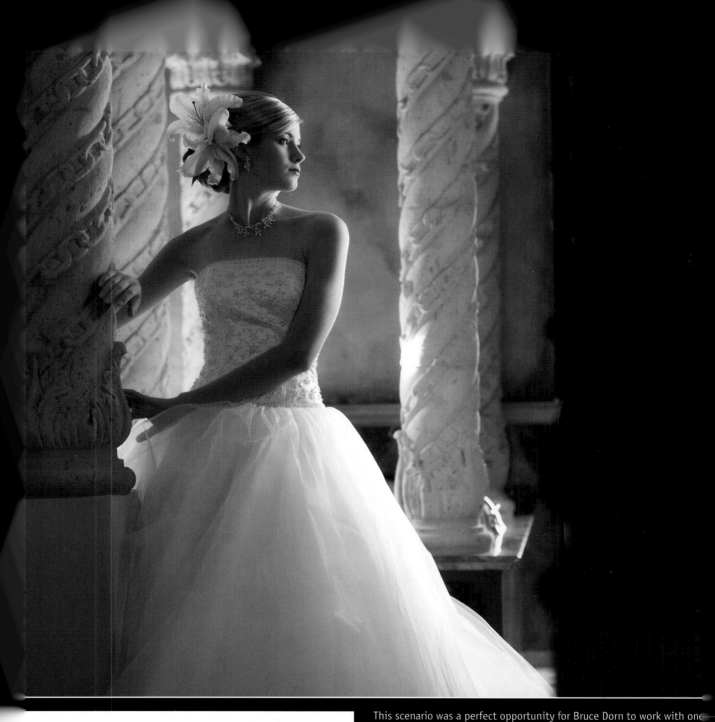

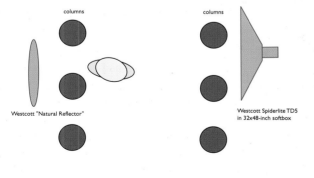

columns

columns

Westcott "Natural Reflector"

Westcott Spiderlite TD5
in 32x48-inch softbox

camera

This scenario was a perfect opportunity for Bruce Dorn to work with one of his favorite lighting instruments: the Westcott Spiderlite TD5 in a Westcott 32x48-inch softbox. The Spiderlite was fitted with Westcott's daylight-balanced fluorescent lamps (5500K). Bruce wanted the skylight to stay slightly cool, so he set the camera's white balance to 5000K. He then warmed up the 5500K light from the Spiderlite, emulating the cozy feel of the tungsten-lit interior, by covering the softbox's front diffuser with a large sheet of Lee Filters' ½ CTO gelatin filter. This gel warms any light source by about 1000K. After carefully placing the softbox slightly beyond the model, Bruce's assistant tucked himself behind a column where he handheld a prototype of the Westcott "Natural Reflector," a pop-open muslin for just a gentle touch of fill. [Excerpted from *Bruce Dorn Presents Vintage Glamour: Exploring Light, Discovering Style*, available from www.idcphotography.com/store.]

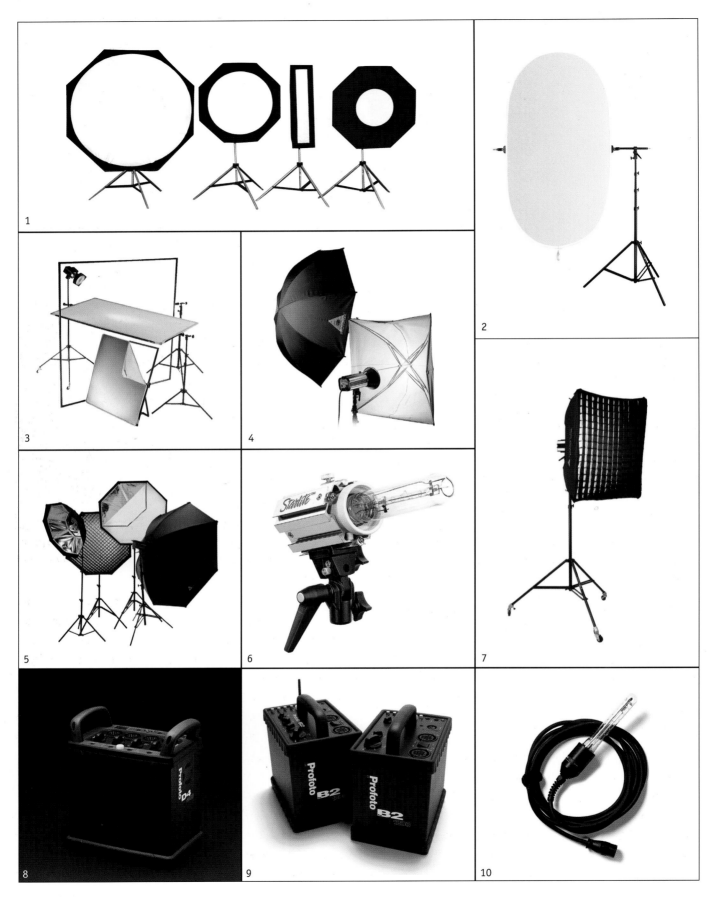

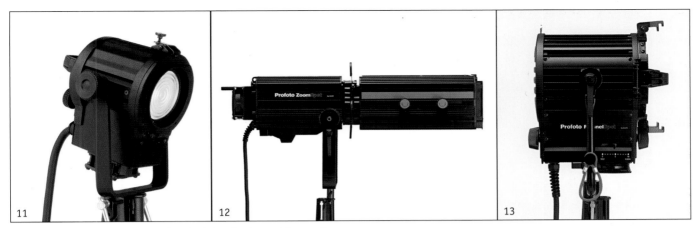

11 12 13

FACING PAGE—(1) Norman Power of Light light-shaping softboxes, from Photo Control Corp., come with a variety of inlaid masks. Designed by Tony Corbell. (2) LiteDiscs also come in oval sizes for a full-length fill or for use as a scrim. (3) Lite Panels from Photoflex are translucent and reflective flexible panels that can be combined to create any kind of lighting on a set or on location. (4) Umbrellas come in a variety of sizes and shapes. Some have opaque backing for maximum light output; others are translucent for shoot-through effects. (5) The Photoflex OctoDome 3 is an eight-sided, space-saving softbox that can be fitted with a variety of internal reflective material and baffles to soften the center of the light. Grids can also be attached. (6) The Photoflex Starlite QL is a 3200K tungsten light for softbox applications. It is cool-working and bright. (7) This Photoflex MultiDome softbox has louvers to focus the light and reduce flare. (8) The Profoto D4 is a 4800Ws power pack that accepts four flash heads, which can be used asymmetrically or symmetrically. (9) The Profoto Pro-B2 is a battery-powered flash system designed for location photography. An internal 32-channel radio receiver is built in for remote operation. (10) The Profoto StickLight is a small and handy lamp head ideally suited for a multitude of lighting effects, including placing the unit inside subjects like furniture, automobiles, and interiors. It can also be used as a hand-held light-painting tool. ABOVE—(11) The Profoto MultiSpot offers a small, directional light source with a direct, sharply focused beam of light. (12) The Profoto ZoomSpot is a large, focusable, light-shaping tool designed to create stage-lighting effects, accent lighting across huge distances, or for background projection. The zoom lens provides an adjustable light spread from 15 to 35 degrees. (13) The Profoto FresnelSpot is a classically sized spotlight that creates "movie light" with sharp, deep shadows and highly saturated color. This FresnelSpot offers lighting adjustments between 10 and 50 degrees.

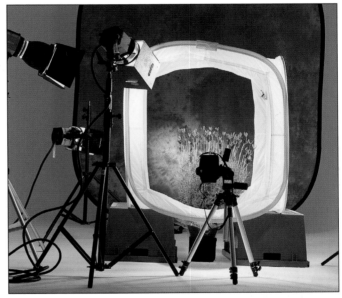

This is a portable light tent from Lastolite with the background slot open. It produces studio lighting for small objects with outdoor backgrounds.

key lights, although they are usually so small that they can be tricky to use for this purpose.

Spotlights. A spotlight (or "spot") is a hard-edged light source. Usually, it is a small light with a Fresnel lens attached. The Fresnel is a glass filter that focuses the spotlight, making the beam of light stay condensed over a longer distance. Barn doors are usually affixed to spots so that they don't spray light all over the set. Spots are often used to light a selected area of the scene, like a corner of the room or a portion of a seamless background. They are usually set to an output less than the key light or fill (although at times they may be used as a key light). Spots produce a distinct shadow edge, giving more shape to the subject's features than lower-contrast, diffused light sources. Although originally a hot light, various strobe manufacturers have introduced strobe versions of Fresnel spots.

Umbrellas. Umbrellas, while not as popular as they once were, are still useful for spreading soft light over large areas. They produce a rounded catchlight in the eyes of portrait subjects and, when used close to the subject, provide an almost shadowless light that shows great

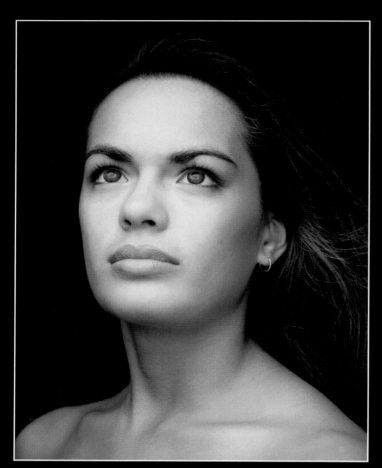

Portable LiteDiscs from Photoflex are flexible reflectors that fold up into a compact shape for transport. They come in a variety of surfaces and sizes and some are reversible. The in-use shots show the effect of gold-foiled LiteDisc used close to the subject.

Here is a Photoflex Half Dome with a grid for better directional control of light. This type of narrow softbox is often used as a diffused hair light or kicker in portrait work. The result shot shows a vase lit with Half Dome and no fill light.

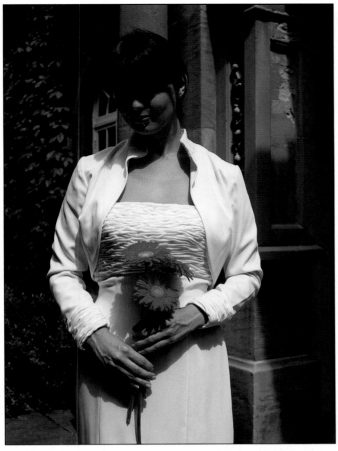

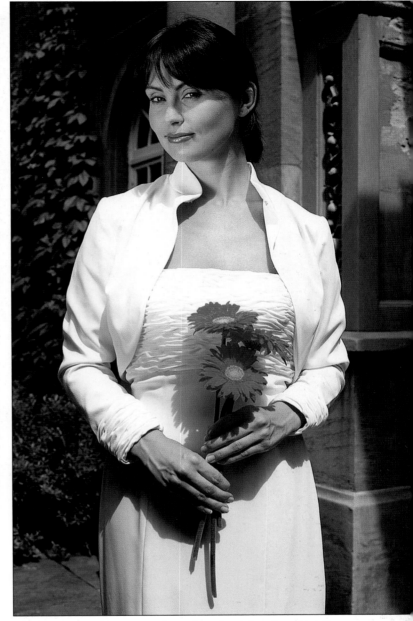

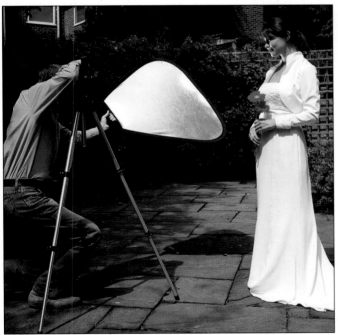

A Lastolite handheld Tri-Grip reflector from Bogen Imaging with before and after images.

forth until the light covers the entire umbrella surface without spill.

Photographic umbrellas are either white or silvered and used fairly close to the subject to produce a soft directional light. A silver-lined umbrella produces a more specular, direct light than a matte-white umbrella. When using lights of equal intensity, a silver-lined umbrella can be used as a key light because of its increased intensity and directness. It will also produce wonderful specular highlights in the overall highlight areas of the face. A

roundness in the human face. Umbrellas are usually used with a wide-angle reflector on the flash head, enabling you to better focus the beam of light for optimal effect (see page 45). This means sliding the umbrella back and

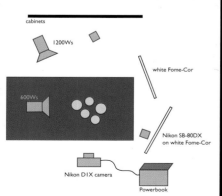

cabinets

1200Ws

white Fome-Cor

600Ws

Nikon SB-80DX
on white Fome-Cor

Nikon D1X camera

Powerbook

Chris LaLonde created this gorgeous beer shot using multiple Bogen strobes (see diagram) and several Nikon SB 80 DX Speedlights as wireless remote strobes for accent lights. The big strobes were used to create backlighting so that the light would skim the foam. His Nikon D1X was tethered to a MacIntosh Powerbook G4 so that he could check sharpness across the image. The Powerbook acts like a giant viewfinder on which to check subtle image details, which is a real advantage for clients or art directors on site. The image was shot in RAW mode at ISO 125 at $1/125$ second at f/8.

matte-white umbrella can then be used as a fill or secondary light.

When shooting with an umbrella, it is important that is be correctly focused. Umbrellas fit inside a tubular housing in most studio electronic flash units. The umbrella slides toward and away from the flash head and is anchored with a set-screw or similar device. The reason the umbrella-to-light-source distance is variable is that there is a set distance at which the optimal amount of strobe light hits the umbrella. This occurs when the light strikes the full surface. If the umbrella is too close to the strobe, much of the beam of light will be focused past the umbrella surface and go to waste. If the light is too far from the umbrella surface, the perimeter of the beam of light will extend past the umbrella's surface, again wasting valuable light output. When setting up, use the modeling light of the strobe to focus the distance correctly, so the outer edges of the light core strike the outer edges of the umbrella.

Some photographers use a translucent umbrella in the reverse position, turning it around so that the light shines through the umbrella and onto the subject. This gives a

An umbrella is a beautiful light source to work with. When used close to the subject, it produces delicate wraparound lighting with no need for a fill source. Photograph by Mark Nixon.

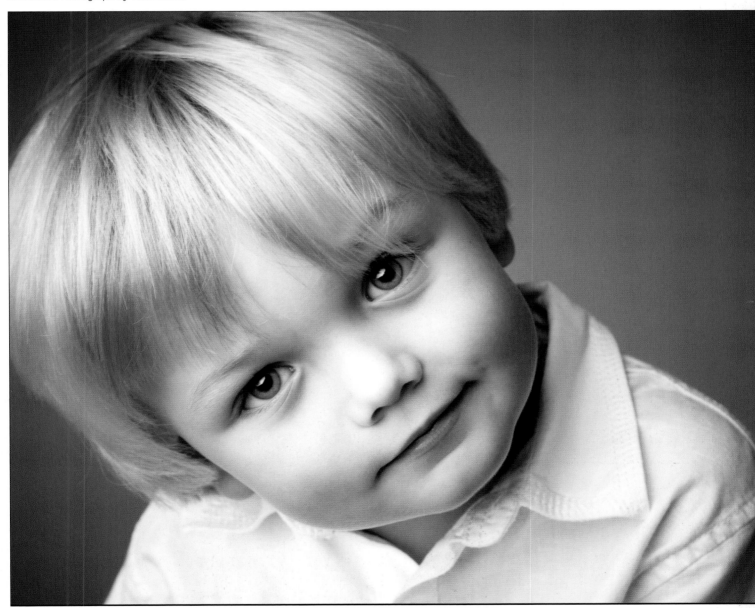

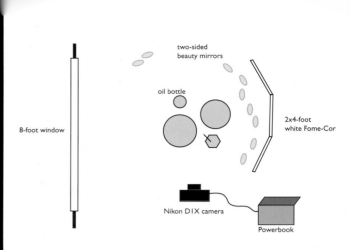

Believe it or not, this beautiful food shoot by Chris LaLonde was made by available light diffused by an oversized scrim in an 8-foot window in Chris's studio. Directly opposite the window was a large 2x4-foot white Fome-Cor reflector, and throughout the set were ten small beauty mirrors on stands. These were used to redirect direct light back onto the food and place set ting, creating effects ranging from gentle soft fill-in light to bright spec ular light for bold highlights on the crawfish. The photo was made with a Nikon D1X and 50mm f/1.4 lens at ⅛ second at f/4 in RAW mode at ISO 125

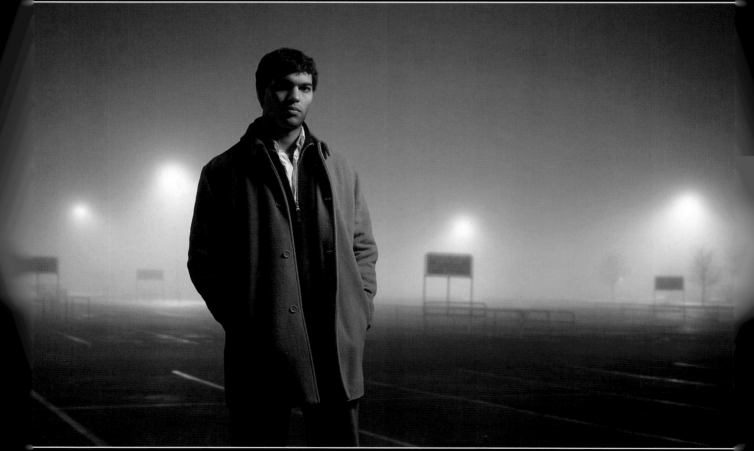

This image is actually two separate shots composited together in Photoshop. Reed Young shot the image in Minneapolis when it was about 2°F outside. According to Reed, "I actually had a model present, but when I turned the modeling lights on they exploded because of the shock of heat to the glass. I learned the hard way on this one. I took the model into the studio and did my best to simulate the street lighting. I placed a strobe about twelve feet in the air to camera right and that was it. I carefully selected him and placed him on the intended background using Photoshop. This is something I

TOP—Anthony Cava captured this remarkable portrait of an old friend who lives near his Ottawa studio. Anthony used a single strobe with a 10-degree grid spot at a steep angle so that the light was almost overhead. The light skimmed across the old man's skin to reveal texture and specular brilliance in the highlights. The grid spot narrowed the beam of light drastically so that it became a narrow but intense shaft of light with a feathered edge. BOTTOM—Fran Reisner created this wonderful portrait using her studio's double doors and a window, which let in soft north light, as a main light. A 4x6-foot softbox and silver reflector redirected daylight back onto the child. In addition, the softbox, with the modeling light extinguished, helped raise the overall level of the fill light. The table lamp used an ordinary household bulb. The image was made with a Canon 1DS Mark II and Canon 35–70mm at 70mm setting. The exposure was 1/60 second at f/6.3, which matched the exposure of the room light. The white balance was set with an ExpoDisc, and the ISO was set to 400.

softer, more directional light than when the light is turned away from the subject and aimed into the umbrella (bouncing it out of the umbrella and back onto the subject). Of course, with a silver-lined umbrella, you can't shine the light through it, because the silvered material is opaque. There are many varieties of shoot-through umbrellas available commercially and they act very much like softboxes.

The Perfect Fill

In a perfect world, fill light would be shadowless, large, and even—encompassing every part of the subject from top to bottom and left to right. The fill light would be soft and forgiving and variable. And it would complement any type of key lighting introduced.

Well, there is such a system and I have seen it used by a number of portrait, fashion, and commercial photographers. The system involves using strobe heads in narrow-angle reflectors bounced into a white or gray wall or flat behind the camera. Usually, one light is used to either side of the camera, and one is placed over the camera and aimed high off the flat or at the wall–ceiling intersection. (*Note:* the walls or flats must be white or neutral for this method to be an effective fill light. Also note that the lights are close to the wall and the "set" where the subject is positioned. Proximity will keep the light soft.)

The lights are balanced to produce the same output across the subject. The key light, which may be from the side or above, will be equal to or more intense than the

Stacy Bratton uses a very large soft light, primarily a 72x54-inch Chimera softbox with an extra baffle in the middle. She uses it straight on and with the bottom edge parallel to the floor so that the catchlights it produces are square, a unique trademark of her lighting. For hair and background light, she bounces light into a drop ceiling (usually white, but sometimes black or gray Fome-Cor board, depending on the desired effect) that is suspended eight feet above the set. This produces incredibly soft fill in, like "the perfect fill," described above. She will change the color of her backgrounds by adjusting the height or intensity of her "up lights," those lights bounced into the suspended boards.

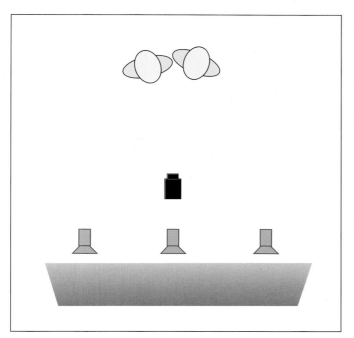

Three studio strobes in wide-angle reflectors are bounced into the rear wall behind the camera to provide a blanket of fill light on the subjects. The lights are adjusted to produce the same exposure across the subjects.

fill source, creating a ratio between the fill and key lights. If positioned to strike the subject from the side, the key light will introduce texture into the subject.

A variation on this setup is to rig a large white flat over and behind the camera. Two or three strobe heads can then be bounced into the flat for the same effect as described above. Some of the light is bounced off the flat and onto the ceiling, providing a very large envelope of soft light.

Reflected Light Values

There are three distinct values of reflected light: specular highlights, diffused highlights, and shadow values. These are sometimes referred to collectively as lighting contrast.

Vicki Taufer is an accomplished family and children's photographer. She uses Photogenic strobes and Larson softboxes. She also uses window light as much as possible. Her studio is equipped with a large bay window that often becomes her key light. She usually uses two softboxes (a 3x4- and a 5x7-foot model; the latter was used here) depending on the type of lighting and the number of people she is photographing. Taufer also uses large 40x70-inch Larson reflectors, especially the Soft Silver and Super Silver models. She does not use a hair or background light.

Acclaimed photographer Gene Martin liked soft but contrasty lighting to bring out the character of his musician subjects. You can see all three reflected light values in this portrait of former Guns 'N Roses guitarist, Slash—specular highlights (pure white), diffused highlights (gradated tone), and shadow values (all the dark areas).

Specular Highlights. Specular values refer to highlights that are pure paper-base white and have no image detail. Specular highlights act like mirrors of the light source. Specular highlights exist within diffused highlight areas, adding brilliance and depth to the highlight.

Diffused Highlights. Diffused highlight values are those bright areas with image detail.

Shadow Values. Shadow values are areas that are not illuminated or partially illuminated.

Small focused light sources have higher specular quality because the light is concentrated in a small area. Larger light sources like softboxes and umbrellas have higher diffused highlight values because the light is distributed over a larger area, and it is scattered.

Shadow Edge. The shadow edge, the region where the diffused highlight meets the shadow value, also differs between these two types of light sources. Depending on the size of the light, the distance of the light from the subject, and the level of ambient or fill light, the transition can be gradual or dramatic. With a small light, the transfer edge tends to be more abrupt (depending, again,

LIGHTING REFLECTIVE OBJECTS

The rule of thumb when lighting a reflective surface is to light *what is reflected into the surface*, rather than the surface itself. Any light shining onto a highly reflective surface, such as glass or metal, will reflect directly into the camera, creating hot spots or specular highlights. Such highlights will be unavoidable if the reflective surface is curved, but the idea is to control what is reflected into the shiny surface. Black will not register as a reflection; it will disappear. White will register as a milky white highlight, depending on the reflectivity of the surface and the distance of the white card from the subject. Transitions within the highlight area are important. For this reason, photographers will often tape black or gray strips onto the white card that is being reflected by the shiny surface.

on the level of ambient light). With larger light sources, the transfer edge is typically more gradual.

Tabletop Lighting

Sweep Table. One of the basic tools of tabletop lighting is the sweep table (sometimes called a cove). This is a

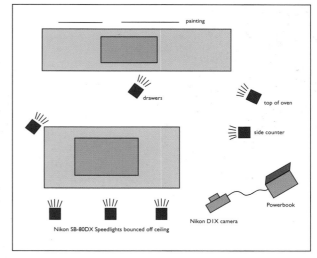

This elaborate kitchen showroom image was done on location by Chris LaLonde using seven Nikon SB-80 DX Speedlights positioned throughout the scene. A Kodak SLRn with a 28–80mm Nikon lens was used and the camera had a Nikon SB-28 Speedlight mounted to the camera hot-shoe to trigger the remote strobes. The main light was from fluorescents overhead. In order to color-correct the strobes, each SB-80 DX used .30 units of green filtration. LaLonde also used Rosco CineFoil around the flash head to shape the light. CineFoil is matte-black aluminum foil that can be molded into any shape and acts like a sculpted gobo to selectively block light. The final image was exposed at $\frac{1}{8}$ second at f/11 in RAW mode at ISO 160.

Many studios are equipped with a professional-grade copy stand and lights for copying flat art—documents, small products, circuit boards, old family photos, etc. Having this capability and promoting it can result in added income during slow periods. Copy work requires precision. Alignment is crucial. When positioning lights, two or four, use an incident meter to determine the evenness of lighting from edge to edge and in the center of your shooting area. All bulbs should be the same age and from the same manufacturer's batch. The exposure reading should be accurate to within $^{1}/_{10}$ stop across the subject plane.

At WPPI, we photograph up to three thousand 16x20-inch competition prints each year with this kind of setup. We use a Canon 5D and capture each frame in RAW mode. Presets include a low contrast setting and a moderate sharpness setting. We use a predetermined exposure and re-test the exposure before each session. From these image files we produce a 350-page book of the winning images from the WPPI print competition.

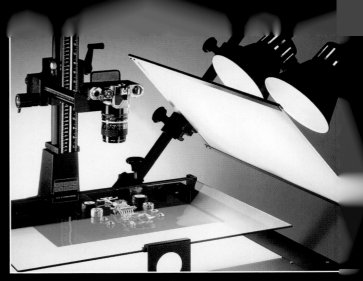

This Bogen Super Repro copy stand has the capability to use a scrim in place over the lights, which diffuses the hard-edged light. It also sport a raised platform and a translucent central rectangle on the copy surface, permitting light to be directed upward through the table for photographing backlit artwork. The Super Repro copy stand accepts fou lights, hot lights or strobes, for perfectly even lighting. The center column is rigid and well marked for precision operation.

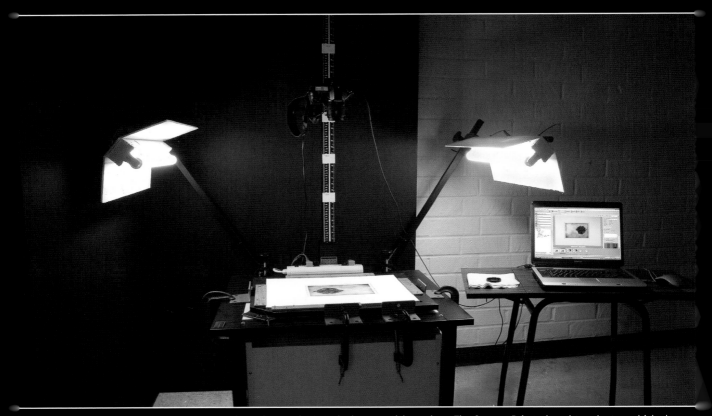

This is the setup we use to photograph up to three thousand 16x20-inch competition prints. The Canon 5D is tethered to a laptop which shows a full-frame JPEG on capture. The lighting is 5500K daylight fluorescent, which is exactly the white balance setting we use on the camera. A custom spring-loaded 16x20-inch easel, designed by photographer David Bentley, holds the prints securely. To prevent the easel from moving, blocks o wood and industrial strength C-clamps hold the easel firmly on the copystand baseboard. The results are quite exceptional.

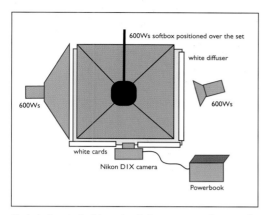

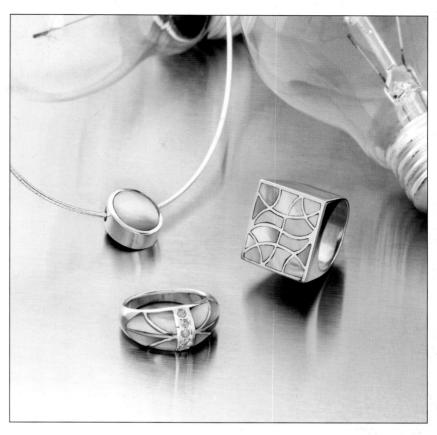

Chris LaLonde fashioned a light tent out of two soft-boxes and a white transparent diffuser. The photo was made with a Nikon D1X, custom-designed close-up lens and three 600Ws White Lightning strobes, two in softboxes. The image was captured directly to Chris's PowerBook G4 laptop so that he could inspect the sharpness at close range. A white cardboard reflector with a hole cut out for the lens was used at the front of the set. The image was exposed in RAW mode at ISO 125 for $\frac{1}{125}$ second at f/16.

translucent Plexiglas table molded into a sweep shape with no horizon line. This allows you to create seamless product photography with even, shadowless lighting. The idea behind the sweep table is that light can be directed onto the subject from any of many possible directions, including underneath. If the overhead lighting matches the intensity of the underneath lighting coming through the Plexiglas, it will be shadowless. Sweep tables come with a variety of accessories, including an exterior frame that will support diffusion material so that the table can be made into a light tent for completely uniform lighting.

Light Tents. Light tents are nothing more than translucent tents that surround a subject. Lights are placed outside the tent to illuminate the subject. A small slit or hole is left in the tent surface so that the camera lens can be positioned. Light tents are ideal for lighting small reflective objects like jewelry, which have dozens of curved, highly reflective surfaces. The idea is to surround the subject in diffused light that is scattered by the translucent tent material.

When photographing reflective objects, everything will reflect the tent surface, which reads as diffuse white. For highlight transitions, small strips of opaque tape (gray or black) are often applied to the inside of the tent surface. Depending on the geometry of the object, these will reflect as black or gray on the object's surface.

Even if you are good at geometry and at determining angles of reflection, complex shapes require lighting by trial and error. You will need to experiment with light placement and distance, as well as transitions within the highlights, and subject placement. Each reflective object is different and will call for a different means of lighting.

EXOTIC AUTOS

Fernando Escovar shoots, among other subjects, exotic automobiles. He has photographed for *Motor Trend* and other automotive magazines and he is an expert. He has even produced a teaching DVD called *Photographing Cars 1.0* (available from www.fotographer.com). Fernando prepares well for each automotive assignment. His gear includes not only the camera but three Photoflex reflectors, additional lighting gear, a small ladder, wrenches and other tools, flashlights, X-acto knives, scissors, rope, tape, glue, string, black spray paint, white water-based paint, and Mother's Wax products. He also takes plenty of DVDs, CDs, an extra hard drive, and extra cameras. In short, he has everything he could possibly need—and backups for the backups.

Fernando will often utilize the services of South Bay Studios in Long Beach, CA, just south of Los Angeles. South Bay rents studios to both photographers and filmmakers and offers fifteen stages (studios) under one roof that can accommodate anything from a tabletop shoot to a feature film. Some of the studios are rigged with Fisher lights, giant 17x52-foot sus-

LEFT—Fernando photographed a Mercedes Brabus edition and included the Fisher Lights as part of the composition to be able to see the hugeness of the light. Notice the roughly 35-degree rake to the light. **BELOW**—This detail shot of the rear end of a Lotus shows the advantages that come with such flash firepower. Small apertures of f/32 provide maximum depth of field, and the big light produces large, beautifully detailed highlights.

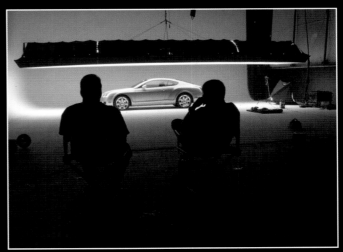

pended softboxes. The Fisher lights are fully adjustable in terms of height and rake (angle). Fernando likes the massive softbox low and set at about a 35-degree rake, depending on the car. This is ideal for producing the long, elegant, creamy highlight that is the Holy Grail for automotive photographers.

The Fisher Lights have ten 400Ws power packs, which together put out a whopping 40,000Ws. Fernando exposes at f/22 or f/32 at ISO 100, capturing images on his Canon EOS 1DS digital system as well as film using a Mamiya RZ67 Pro II camera. The giant softbox takes between 10 to 15 seconds to recycle, so he shoots slowly. He says, "I like to photograph from various angles and incorporate a ladder to shoot down on the car. This entire process normally allows for only one or two cars per day, although I have done as many as twelve when the client only requires the basics."

As for the crew, on many car shoots Fernando will use a model, so he normally works with three to six people, including a production coordinator, stylist, makeup artist, and assistants, as needed.

4. Basic Portrait Lighting

Portrait lighting imitates natural lighting. It is a one-light look. In other words, even though numerous lights may be used, one light must dominate and establish a pattern of shadows and highlights on the face. All other lights are secondary to the key light and modify it. The placement of the key light is what determines the lighting pattern in studio portraiture.

The shape of the subject's face usually determines the basic lighting pattern that should be used. You can widen a narrow face, narrow a wide face, hide poor skin, and disguise unflattering facial features, such as a large nose, all by thoughtful placement of your key light.

Basic Portrait Lights

These lighting techniques can be done with very basic equipment. A full set of four lights with stands and parabolic reflectors can be purchased quite reasonably. The lights can be electronic flash units or they may be incandescent lights. The latter is preferred in learning situa-

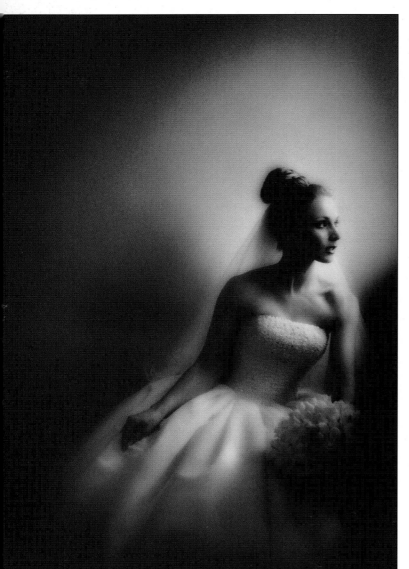

The portrait lighting pattern is defined by one light, the main light. Here, in a striking bridal formal by Martin Schembri, a single shaft of light above and to the side of the bride created the classic Rembrandt lighting pattern. According to the photographer, "This image was shot with available light streaming through the bride's bedroom. It was quite strong and not as diffused as I would have liked. I decided to sit the bride on a bench located just below the windowpane and expose for the spill light coming through the window. This helped create the halo effect around the bride. With a little help in Photoshop, I managed to tone down the highlights on the wall to concentrate the lighting on the bride." The image was shot digitally, using a Nikon D100 and 35–70mm f/2.8 zoom lens.

Frances Litman made this charming portrait with a soft key light and a backlight to highlight the subject's hair and put a subtle rim around his arm and shoulder. The use of backlights, like hair lights and kickers, adds drama and dimension to the lighting.

tions, because what you see is exactly what you get. With strobes, a secondary modeling light is used within the lamp housing to approximate the effect of the flash.

Key and Fill Lights. The key and fill lights should be high-intensity bulbs seated in parabolic reflectors. Usually 250–500W is sufficient for a small camera room. If using electronic flash, 200–400Ws per head is a good power rating for portraiture. Reflectors should be silver-coated on the inside to reflect the maximum amount of

light. If using diffusion, such as umbrellas or softboxes, the entire light assembly should be supported on sturdy stands or boom arms to prevent them from tipping over.

The key light, if undiffused, should have barn doors affixed. Barn doors ensure that you light only the parts of the portrait you want lit. They also keep stray light off the camera lens, which can prevent lens flare.

The fill light should be equipped with a diffuser (see pages 47–49). Like the key, it should have barn doors at-

tached. If using a diffused fill-light source, such as an umbrella, be sure that you are not "spilling" light into unwanted areas of the scene, such as the background. As with all lights, fill-light sources can be feathered, aiming the core of light away from the subject and using just the edge of the light beam.

Hair Light. The hair light, which is optional if you're on a budget, is a small light. Usually, it takes a scaled-down reflector and a reduced power setting (because hair lights are almost always used undiffused). Because this light is placed behind the subject to illuminate the hair, barn doors or a snoot are a necessity; without such control, the light will flare.

Background Light. The background light is also a low-powered light. It is used to illuminate the background so that the subject will separate from it tonally. The background light is usually placed on a small stand directly behind the subject and out of view of the camera. If used this way, the background light is often a barebulb that spills light in a 360-degree pattern. It can also be placed on a higher stand and directed onto the background from either side of the set.

Kicker Lights. Kickers are optional lights used very much like hair lights. These add highlights to the sides of the face or body to increase the feeling of depth and richness in a portrait. Because they are used behind the sub-

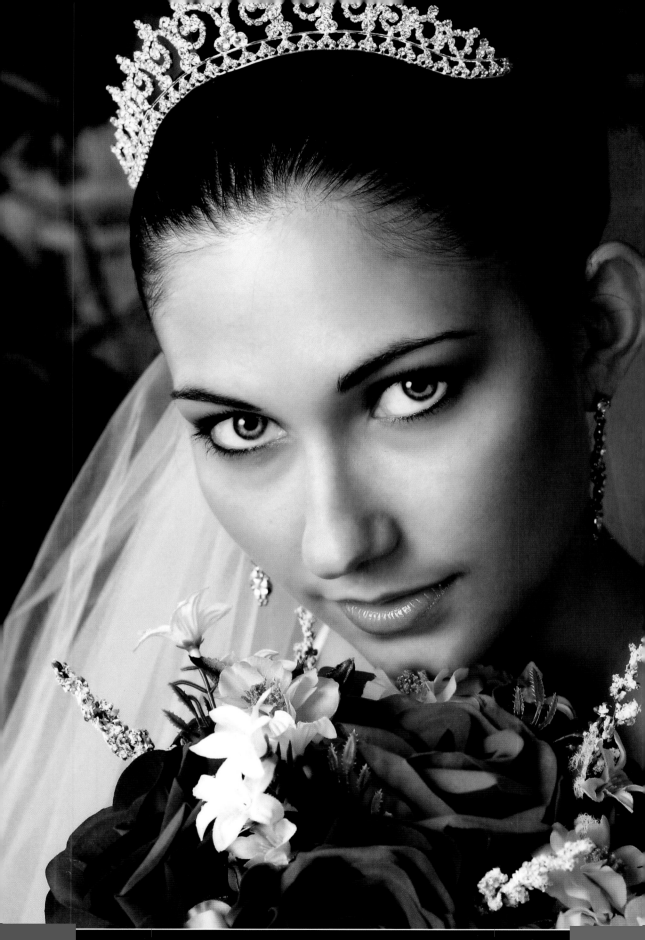

FACING PAGE—A single light source was used to photograph two sisters, who apparently could not be more different. The girl on the left is looking into the light, her pose tall and straight, while her sister looks away from the light, somewhat symbolically, and her pose is much more casual. Two sisters, two personalities—it's a concept that Vicki Taufer illustrated perfectly with a single softbox. ABOVE—Award-winning portrait photographer Norman Phillips created this happy portrait by flooding the white background from either side with undiffused floodlights. As the reflected light passed through the draped white curtains it was further diffused, wrapping around the profiles of the tiny dancers. Frontal fill was accomplished by bouncing light off the back walls of the studio.

ject, the light just glances off the skin or clothing and produces highlights with great brilliance. Barn doors or snoots should be used to control these lights.

Broad and Short Lighting

There are two basic types of portrait lighting, broad lighting and short lighting. In broad lighting, the key light illuminates the side of the face turned toward the camera. Broad lighting tends to flatten out facial contours and widen the face. In short lighting, the key light illuminates the side of the face turned away from the camera. Short lighting emphasizes facial contours and can be used to narrow a round or wide face. When used with a weak fill light, short lighting produces a dramatic lighting with bold highlights and deep shadows. Because it enhances the shape of the face, short lighting is used more frequently than broad lighting.

The Five Basic Portrait-Lighting Setups

As you progress through the following lighting setups, from Paramount to split lighting, keep in mind that each pattern progressively makes the face slimmer. Each also

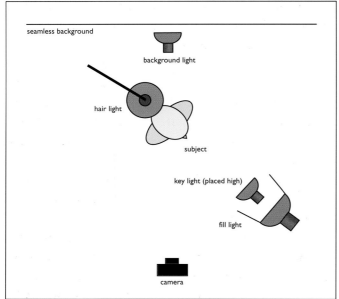

PARAMOUNT LIGHTING

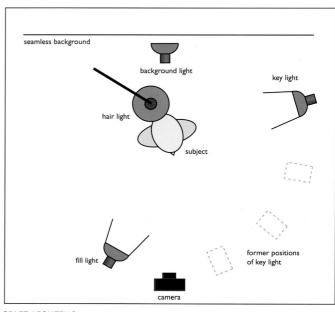

LOOP LIGHTING

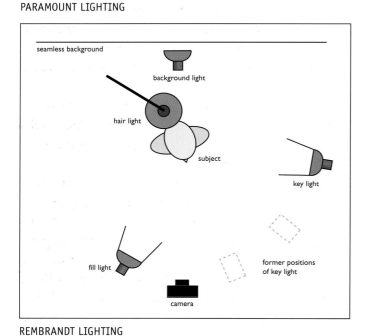

REMBRANDT LIGHTING

SPLIT LIGHTING

progressively brings out more texture in the face because the light is moved father and farther to the side. As you read through the lighting styles, you'll also notice that the key light mimics the course of the sun across the sky; at first it is high, then it gradually grows lower in relation to the subject. It is important that the key light never dip below the subject's head height. In traditional portraiture, this does not occur—primarily because it does not occur in nature.

The setups described presume the use of parabolic lights. However, most contemporary portrait photogra-

phers prefer diffused light sources, which are very forgiving and which do not create sharp-edged shadows. If you choose to create the five lighting patterns described here using diffused sources, very little changes—with the exception that the key light is usually placed closer to the subject in order to capitalize on the softest light.

In such soft-light setups, the background, hair, and kicker lights may be diffused as well. For instance, strip lights and similar devices can be used to produce soft, long highlights in hair, on the edge of clothes, and on the background.

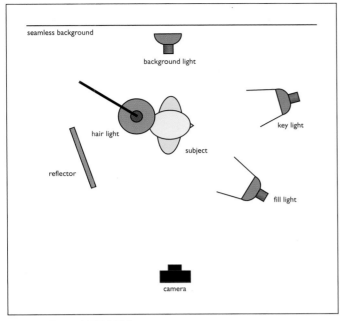

PROFILE OR RIM LIGHTING

FACING PAGE AND ABOVE—These diagrams show the five basic portrait lighting setups. The fundamental difference between them is the placement of the key light. Lighting patterns change as the key light is moved from close to and high above the subject to the side of the subject and lower. The key light should not be positioned below eye level, as lighting from beneath does not occur in nature. You will notice that when the key and fill lights are on the same side of the camera, a reflector is used on the opposite side of the subject to fill in the shadows.

The overall aesthetic of using soft light is not only seen as more contemporary, emulating the images seen in the fashion world, it is also a lot easier to master. Big soft light sources are inherently forgiving, and since the subject is basically wrapped in soft light, retouching is minimized. Also, the transfer edge, where shadow and highlight areas meet, is much more gradual than with undiffused lights.

Paramount Lighting. Paramount lighting, sometimes called butterfly lighting or glamour lighting, is a traditionally feminine lighting pattern that produces a symmetrical, butterfly-like shadow beneath the subject's nose. It tends to emphasize high cheekbones and good skin. It is less commonly used on men because it tends to hollow out cheeks and eye sockets too much.

Key Light. For this lighting setup, the key light is placed high and directly in front of the subject's face, parallel to the vertical line of the subject's nose (see diagram on facing page). Since the light must be high and close

to the subject to produce the desired butterfly shadow, it should not be used on women with deep eye sockets, or no light will illuminate the eyes.

Fill Light. The fill light is placed at the subject's head height directly under the key light. Since both the key and fill lights are on the same side of the camera, a reflector must be used opposite these lights and in close to the subject to fill in the deep shadows on the neck and shaded cheek.

Hair Light. The hair light, which is always used opposite the key light, should light the hair only and not skim onto the face of the subject.

Background Light. The background light, used low and behind the subject, should form a semicircle of illumination on the seamless background (if using one) so that the tone of the background grows gradually darker the farther out from the subject you look.

Loop Lighting. Loop lighting is a minor variation of Paramount lighting. This is one of the more commonly used lighting setups and is ideal for people with average, oval-shaped faces.

Key Light. To create this setup, the key light is lowered and moved more to the side of the subject so that the shadow under the nose becomes a small loop on the shadow side of the face.

Fill Light. The fill light is also moved, being placed on the opposite side of the camera from the key light and close to the camera–subject axis. It is important that the fill light not cast a shadow of its own in order to maintain the one-light character of the portrait. The only position from which you can really observe whether the fill light is doing its job is at the camera. Check carefully to see if the fill light is casting a shadow of its own by looking through the viewfinder.

Hair and Background Lights. The hair and background lights are used in the same way as they are in Paramount lighting.

Rembrandt Lighting. Rembrandt lighting (also called 45-degree lighting) is characterized by a small, triangular highlight on the shadowed cheek of the subject. The lighting takes its name from the famous Dutch painter who used skylights to illuminate his subjects. This type of lighting is dramatic. It is most often used with male subjects, and is commonly paired with a weak fill light to accentuate the shadow-side highlight.

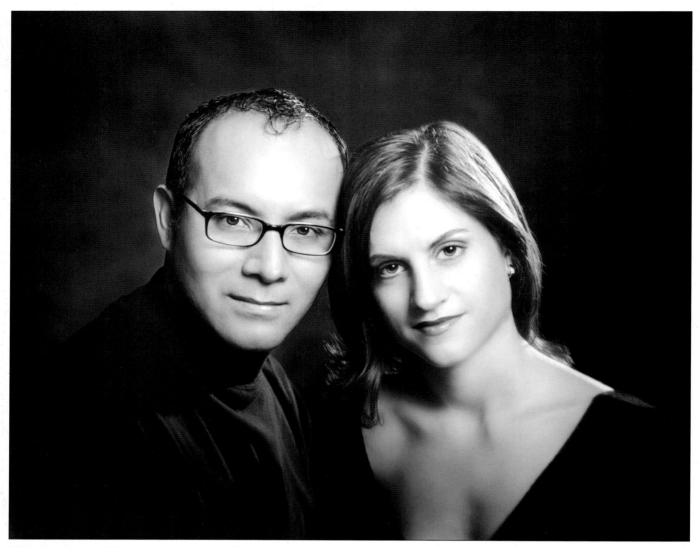

Bill McIntosh created this homage to Hollywood lighting using a 31-inch umbrella as a key light and a weak umbrella fill light, about three stops less than the key-light intensity. You can see the Paramount lighting pattern on the man produced a small butterfly-like shadow under the nose. The woman's face, because her head was turned slightly toward the light, has more of a loop lighting pattern. A characteristic of the Hollywood style was the weak fill light, which enhanced not only the lighting contrast, but the dramatic nature of the lighting.

Key Light. The key light is moved lower and farther to the side than in loop and Paramount lighting. In fact, the key light almost comes from the subject's side, depending on how far his head is turned from the camera.

Fill and Hair Lights. The fill light is used in the same manner as it is for loop lighting. The hair light, however, is often used a little closer to the subject for more brilliant highlights in the hair.

Background and Kicker Lights. The background light is in the standard position described above. With Rembrandt lighting, however, kickers are often used to delineate the sides of the face (particularly the shadow side) and to add brilliant highlights to the face and shoulders.

When setting such lights, be careful not to allow them to shine directly into the camera lens. The best way to check this is to place your hand between the subject and the camera on the axis of the kicker. If your hand casts a shadow when it is placed in front of the lens, then the kicker is shining directly into the lens and should be adjusted.

Split Lighting. Split lighting occurs when the key light illuminates only half the face. It is an ideal slimming light. It can be used to narrow a wide face or nose. It can also be used with a weak fill to hide facial irregularities. For a highly dramatic effect, split lighting can be used with no fill.

CLAUDE JODOIN ON TODAY'S GLAMOUR LIGHTING

Traditionally, glamour lighting has been done with the main light placed directly over the subject, then aimed down to create a distinct butterfly-shaped shadow under the nose. This is not a "corrective" way to light a face. It is used to emphasize faces that have a symmetrical structure—faces found primarily on those rare creatures we call "professional models." Until the introduction of color films and 16- to 20-inch parabolic flash sources in the 1950s, Hollywood photographers like George Hurrell also lit their movie-star subjects in this manner, pairing tungsten spotlights with 8x10 black & white film. For this reason, this lighting pattern is also commonly known as Paramount lighting.

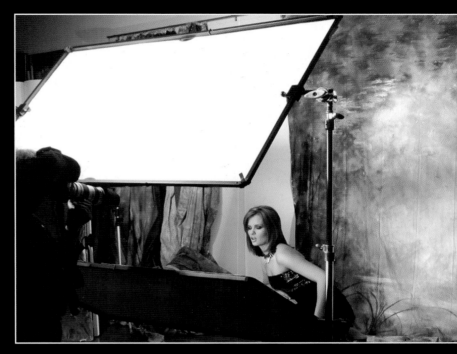

Today's typical glamour headshots are done on digital cameras in color with soft flash sources of various sizes, so the butterfly pattern is not as obvious as it was in the old days of small main lights. Today, it mostly refers to the 12 o'clock catch light created by the larger sources of illumination. By using one or more silver or white reflectors beneath the chin of the model, we create a second catch light at 6 o'clock position. This type of lighting is very useful for model headshots. This central placement allows for facial and body movements left to right, from full face to two-thirds view, creating a modified butterfly pattern, while working on various expressions that define the subject's personality. Varying the size of the light source changes the shadow edge transfer characteristic to help shape the nose and cheekbone characteristics. This gives us very little corrective control as compared to other classic lighting patterns and positions, so, as a rule (which can be broken), we should reserve this mostly for photogenic subjects.

This setup is what Claude Jodoin calls the "glamour wedge," with the flash aimed down to fill the 3½x6-foot diffuser. A silver reflector of the same dimensions down below kicked up the fill at about 60 percent of the diffused main-light intensity. Not shown is a 150W Cameron 800 Metal Halide light (sold by Booth in Ontario, Canada) that was added a while later in the shoot. It has a 5200K daylight balance and serves as a very bright focusing light, which reveals more color in the model's eyes. Photograph by Claude Jodoin of Crystal Hayes, Miss Michigan USA, 2005.

Key Light. In split lighting, the key light is moved farther to the side of the subject and lower than in other setups. In some cases, the key light is actually slightly behind the subject, depending on how far the subject is turned from the camera.

Other Lights. The fill light, hair light, and background light are used normally for split lighting.

Profile Lighting. Profile lighting (also called rim lighting) is used when the subject's head is turned 90 degrees from the camera lens. It is a dramatic style of lighting used to accent elegant features. It is used less frequently now than in the past, but it still produces a stylish portrait.

Key Light. In rim lighting, the key light is placed behind the subject so that it illuminates the profile of the subject and leaves a polished highlight along the edge of the face. The key light will also highlight the hair and neck of the subject. Care should be taken so that the accent of the light is centered on the face and not so much on the hair or neck.

Fill Light. The fill light is moved to the same side of the camera as the key light and a reflector is used to fill in the shadows (see the profile-lighting diagram on page 62).

Hair and Background Lights. An optional hair light can be used on the opposite side of the key light for better tonal separation of the subject's hair from the background. The background light is used normally.

The Finer Points

In setting the lights for the basic portrait-lighting patterns discussed here, it is important that you position the lights with sensitivity.

Overlighting. If you merely aim the light directly at the subject, there is a good chance you will overlight the subject, pro-

TOP—Allegro Haynes is a talented violinist who plays with the Virginia Symphony and the Harbor String Quartet. She is frequently featured as a solo violinist. Bill McIntosh wanted this portrait to look as if could be a movie set in the eighteenth or nineteenth century. He used a 31-inch umbrella as the key light and a weak umbrella fill set at about three stops less than the key. Two small kickers from the right and left rear of the subject lit her hair, and a small background light illuminated the painted background. The lighting pattern falls between the Rembrandt and loop lighting patterns. **ABOVE**—Split lighting divides the face into halves—one side highlighted, one side in shadow. Vicki Taufer used large softboxes to produce a wraparound light on the highlight side of the face and a silver reflector on the shadow side to produce a moderate lighting ratio and good facial modeling.

ducing pasty highlights with no delicate detail. Instead, you must adjust the lights carefully, one at a time, and then observe the effects from the camera position. Instead of aiming the light so that the core of light strikes the subject, feather it so that you employ the edge of the light. Keep in mind that, since you are using the edge of the light, you will sometimes cause the level of light to drop off appreciably with no noticeable increase in highlight brilliance. In these cases, it is better to make a slight lateral adjustment of the light in one direction or the other. Then check the result in the viewfinder.

Key-Light Distance. Sometimes you will not be able to get the skin to "pop," regardless of how many slight adjustments you make to the key light. This probably means that your light is too close to the subject and you are overlighting. Move the light back. A good working distance for your key light, depending on your room dimensions, is eight to twelve feet.

Fill-Light Distance. The fill light can pose its own set of problems. If it's too close to the subject, it often produces its own set of specular highlights, which show up in the shadow area of the face and make the skin ap-

Larry Peters created this fine profile portrait using rim light from a softbox behind and to the left of the subject. The light was feathered to create texture on the young man's skin. An undiffused hair light was used above and to the right of the camera (from behind the subject) and produced an edge highlight on his collar and hair. Larry also used a reflector to spill some light onto the frame of the Versace sunglasses. Very little frontal fill was used to keep the portrait edgy.

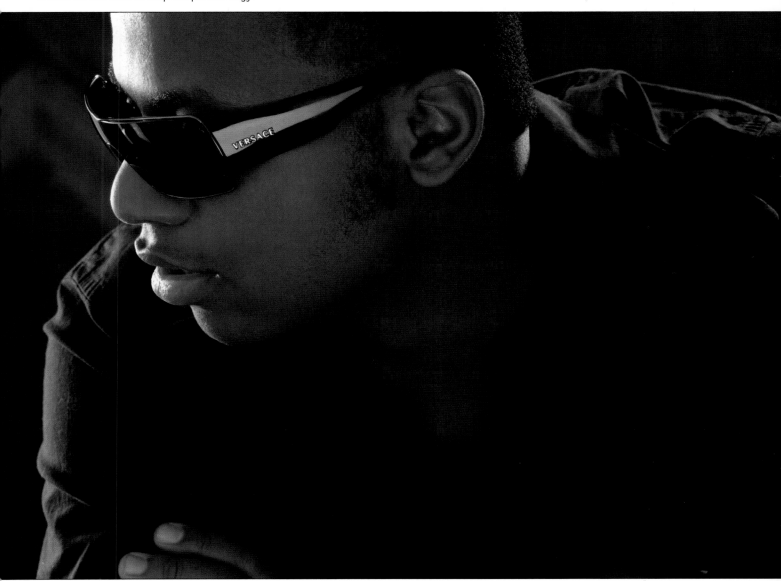

pear oily. If this is the case, move the camera and light back slightly, or move the fill light laterally away from the camera slightly. You might also try feathering the light in toward the camera. This is preferable to closing down the barn doors of the light to lower its intensity.

Multiple Catchlights. Another problem that the fill light often creates is multiple catchlights in the subject's eyes. These are small specular highlights in the iris of the eye. The effect of two catchlights (one from the key light, one from the fill light) is to give the subject a dumb stare or directionless gaze. This second set of catchlights is usually removed in retouching.

Setting the Lights

Most photographers have their own procedures for setting the portrait lights. You will develop your own system as you gain experience, but the following provides a good starting point.

Background Light. The background light, if you are using one, is usually set up while all other lights are turned off. Place it behind the subject, illuminating the part of the background you want lit. Usually, the background light is slightly hotter (brighter) very close to the subject and fades gradually the farther out from the subject you look. This is accomplished by angling the light downward. If you have more space in front of than behind the subject in the composition, the light should be brighter behind the subject than in front (as seen from the camera). This helps increase the sense of direction and depth in the portrait.

Hair Light. Next, the hair light (if using one) is set. This is also set up with your frontal lights extinguished so

Joseph and Louise Simone created this portrait using Photogenic lights in parabolic reflectors with barn doors and diffusers. The main light, a 16-inch parabolic, was set to produce an output of f/11.5 and positioned for a classic Rembrandt diamond on the shadow side of the face. The fill light was set to produce an f/8 output. The accent light was another 16-inch parabolic and it was set to output between f/5.6–6.7. The backlight was a Photogenic Veil Reflector and it produced an f/8.5 output. The background was projected using the Virtual Background system.

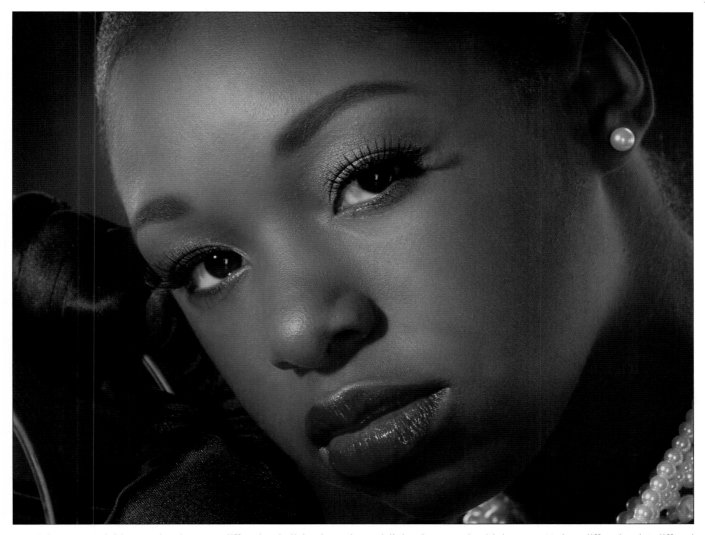

Fran Reisner created this portrait using an undiffused main light above the model's head on an axis with her nose. Various diffused and undiffused light sources were used both for fill and for accent (see diagram). Since the main light was undiffused and came from an angle, it produced texture and great highlight brilliance. Often these details are a function of feathering the main light until the skin "pops" with specularity.

that you can see any stray light falling onto the face. If this happens, adjust the light until it illuminates only the hair. When photographing men, the hair light can sometimes double as a kicker, illuminating the hair and one side of the forehead or cheek simultaneously.

Fill Light. Next, the fill light is set. Usually it is used next to the camera (see the lighting diagrams on pages 62 and 63). Adjust it for the amount of shadow detail and lighting ratio you want to achieve.

Examine the subject's face with only the fill light on and determine if the skin looks oily or normal. If adjusting the fill light doesn't correct the problem, you will have to use a pancake base makeup to dry up the skin. If the skin looks too matte and lifeless, increase the amount of fill.

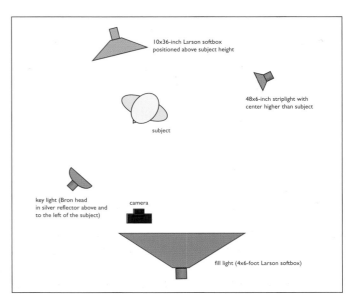

10x36-inch Larson softbox positioned above subject height

48x6-inch striplight with center higher than subject

subject

key light (Bron head in silver reflector above and to the left of the subject)

camera

fill light (4x6-foot Larson softbox)

Key Light. Next, turn on the key light and adjust it for the desired lighting pattern and ratio. Move it closer to or farther from the subject to adjust the ratio. Ratios are best metered by holding an incident light meter first in front of the shadow side of the face, and then in front of the highlight side—in each case pointing the meter directly at the light source. Meter the lights independently with the other extinguished. This will give you an accurate reading for each light. Meter the exposure with both frontal lights on and the incident-light dome pointing directly at the camera lens.

Fuzzy Duenkel's One-, Two- and Three-Light Setups

Fuzzy Duenkel is well known for his sophisticated senior portraits. While he transports his studio-lighting setups to make stunning portraits in the subject's home, these techniques are equally applicable to studio shoots. As you'll see, Fuzzy's lighting technique differs significantly from the traditional portrait lighting setups described above, yet there are similarities. He uses one key light with ample fill. He also uses a background light and kickers (what he calls "edge lights") to illuminate the perimeter of his subjects. The following descriptions cover three

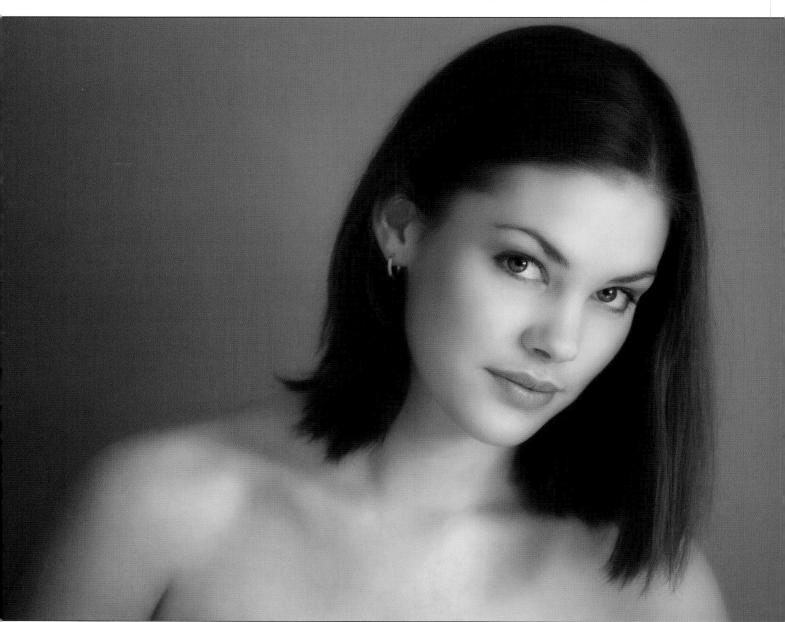

In the one-light setup, the large softbox is used close to the subject and the frontal reflector, which also gobos the camera and lens, broadens the light for an elegant, diffuse highlight. The background is lit mostly from spill from the main light and reflectors. Photograph by Fuzzy Duenkel.

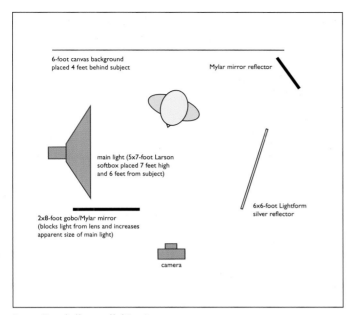

Fuzzy Duenkel's one-light setup.

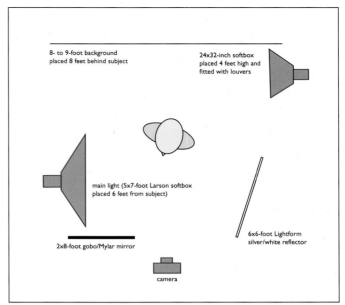

Fuzzy Duenkel's two-light setup.

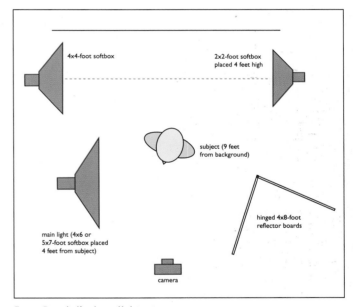

Fuzzy Duenkel's three-light setup.

of his more frequently used setups, employing one, two, and three lights, respectively.

One-Light Setup. Fuzzy's one-light setup uses a single key light, a 5x7-foot softbox set at about chin height and forward of the subject (facing page, top left).

A large 6x6-foot silver reflector is the only fill, and it is used close to the subject. A homemade Mylar mirror reflector is used to redirect light from the key light back onto the subject. Fuzzy calls this an edge light because it illuminates the side or hair or torso of the subject, depending on where it is aimed.

One other interesting feature of this setup is that a large gobo (2x8-feet) is used to block light from hitting the camera, which could cause flare. The opposite side of the gobo is mirrored Mylar to increase the relative size of the key light. You will notice that the canvas background is not lit separately. It is pulling light from the key light and reflector and is only positioned four feet from the subject, as seen in the following diagram. You will see, in subsequent setups, that the larger and farther the background is from the subject, the more it needs its own light source.

Two-Light Setup. The same 5x7-foot softbox and 6x6-foot silver reflector are used as in the one-light setup, as is the mirrored gobo, which is used to minimize flare and expand the key light's apparent size.

Note that, in the diagram (top right), the subject is eight feet from the background, which is farther than in the first example. Thus, a 24x32-inch Chimera softbox is used to light the background and produce an edge light on the subject. The light can be feathered toward the background for more emphasis, or it can be feathered toward the subject for stronger backlight. The removable louvers control the amount of edge light and also prevent stray light from causing flare. An optional barn door (or gobo) may be used between the background light and subject to control the amount of edge light and shield the camera from stray light, which might cause flare. The gobo is used in case you want to remove the

louvers from the softbox for more light on the subject and less feathered light on the background.

It is important to control the difference in output between the key light and the background light. Fuzzy aims for f/11 from the key light, then sets the background light to produce f/8 for low-key backgrounds, or f/16 for high-key backgrounds.

Three-Light Setup. The main difference with this setup is that a second background light is used to add double-edged lighting on the subject (or for high-key backgrounds). You will note in the diagram (above) that a hinged reflector is used very close to the subject, just out of view of the camera. This reflector, like so many of Fuzzy's lighting accessories, is homemade from insulation boards and is white on one side and silver on the other. The other part of the reflector is being used as a gobo to keep stray light from hitting the camera lens.

As with the other lighting setups, the key light is positioned just under chin height. This keeps light in the eyes and helps avoid what Fuzzy calls "dark eye bags." It should be noted that while softboxes are used as a key light in all three setups, a flash bounced into a white wall may be used in tight quarters. Fuzzy normally uses an f/8 setting for the key light with a background light setting between f/5.6 and f/8. In all three lighting setups, Fuzzy also recommends adjusting the fill reflector by eye.

The above information is from Fuzzy Duenkel's CD, entitled *Fuzzy Logic*, which is available from his web site: www.duenkel.com.

Favorite Lighting Setups

Lighting is like painting: no two people do it alike. Because individual techniques

ABOVE—Fuzzy Duenkel's lighting is exquisite and flawless. Soft, flattering light is his specialty, but he knows how to use it to sculpt a face to perfection. FACING PAGE—Whether Fuzzy Duenkel uses one, two or three lights, the effect is the same—a big soft key with strong fill-in from the hinged 4x8-foot reflector and good lighting in the background. This image used two smaller softboxes for the background as in the three-light setup.

can vary so widely, I asked a number of photographers to relate their favorite lighting setup. The following are a few of their responses. Others are scattered throughout the book.

Bill McIntosh. Since Bill shoots so many of his portraits on location, he uses as many strobes as are required to light the room, the background, and the subject. He uses Calumet Travelite strobes frequently, and his key light is often a 31-inch umbrella. His fill light is normally a 32-inch umbrella. Other lights may be used diffused or in their parabolic reflectors, depending on his needs. He will often use lights in reflectors with barn doors—

particularly when he wants to increase the contrast of the light in a specific area of the portrait or on the subject. He has been known to use as many as twelve strobes to light huge areas, like the stage of an opera house or the gallery of a museum. McIntosh is also a big proponent of barebulb flash, often as an outside key-light source with daylight used as a fill light.

Stacy Bratton. Stacy is a children's photographer who uses soft, large lights—primarily a 72x54-inch Chimera softbox with an extra baffle. She uses it straight on and with the bottom edge parallel to the floor so that the catchlights are square, a trademark of her lighting.

In school, Stacy learned to light her seamless with two umbrellas, but her first studio did not accommodate that much width and depth for lights. Therefore, she adapted a different approach, bouncing light into a white drop ceiling above the set to serve as a hair light and lighten up the colored seamless background. Although her 11,000-square-foot studio can now accommodate any and all lighting setups, she still employs this lighting strategy because it requires less power, fewer heads, and less effort. She says, "I can change a yellow background from mustard yellow to pale yellow by moving my 'up-light' [the light aimed at the drop ceiling of white flats] a few inches, and powering up or powering down the power pack." Alternately, she changes her key-light power or placement in relation to the subject to adjust the ratio of the foreground to background light.

Larry Peters. Larry is a well-known senior photographer and a lighting expert. In his studio, he prefers a 42-inch softbox for the key light and a Photogenic Silfoil 4x6-foot reflector for the fill. Larry also has a 4x6-foot softbox permanently mounted on the ceiling, which acts as a hair light and also separates the subject from the background by adding a soft glow around the shoulders. Occasionally, he also uses 12-inch square softboxes as edge lights to further separate the subject from the background.

The final light used in this particular setup is the background light, which is usually used with 5-inch parabolic reflector and a holder for colored gels. The same light can also be used as a barebulb source, with the gel wrapped around the flash tube. The barebulb lights the background and also throws color on the subject's hair from underneath, producing a very different look. The power of this light source is determined by the color of the gel used. His experience has been that when warm colors such as red or amber are used, the light needs less power than if cool colors are used.

In using so many secondary lights, Peters has found that as long as the output is less than for the key light, you can add as many lights as you need. If the

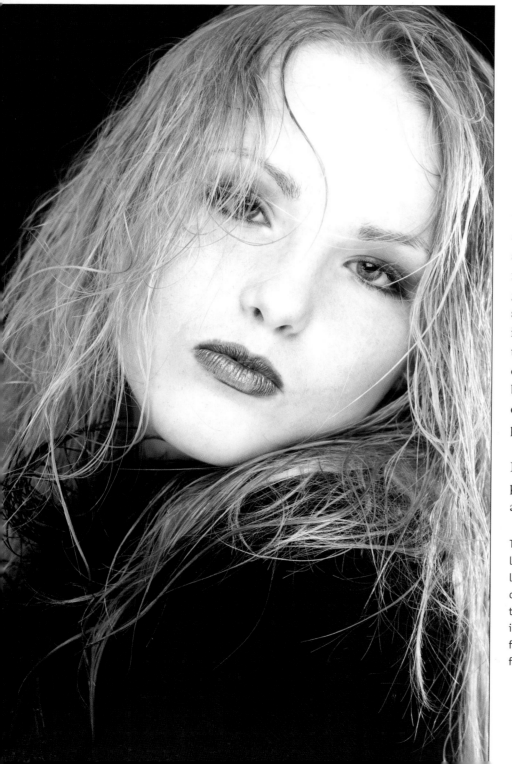

True fashion lighting is on-axis with the camera lens. Here, Larry Peters has a large softbox atop the lens and a reflector beneath the lens to produce a column of shadowless light. Since the lighting in these types of shots does not contour the face, it is important that make-up be expertly applied to define the cheekbones and other frontal planes of the face.

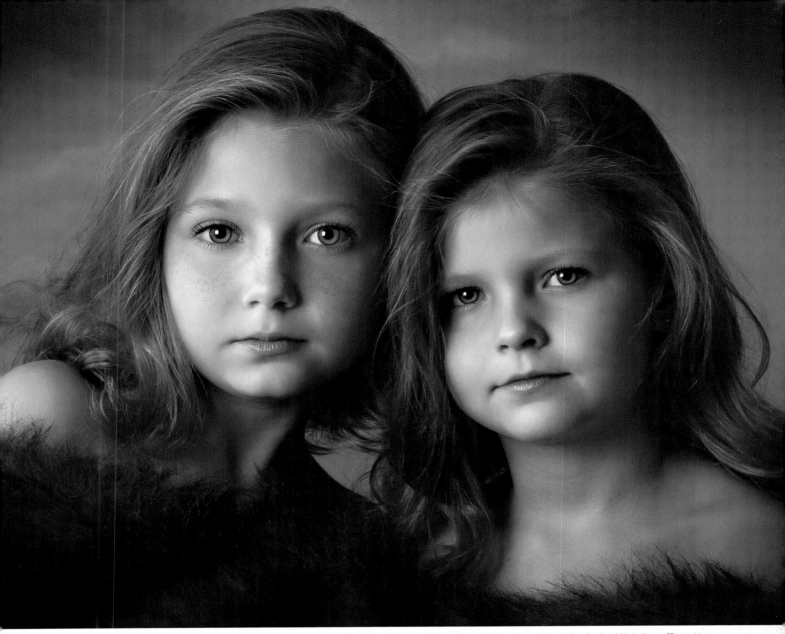

One of the tricks to using softboxes and umbrellas is determining the right distance from the subjects to produce the desired lighting effect. Here, Vicki Taufer used a single softbox at a 45-degree angle to the subjects to create *Little Divas*. If the light had been used closer to the girls, it would have been softer and produced broader, more diffuse highlights. By backing the light off a bit, Vicki was able to create more drama and contrast, just the effect she was striving for.

main light calls for an exposure of f/8, for example, the hair light should meter at f/5.6 or a little less. He cautions against letting any of these lights exceed the output of the key light, as they will cast unnatural shadows.

Vicki Taufer. Vicki Taufer is an accomplished family and children's photographer. She uses Photogenic strobes and Larson softboxes. She also uses window light as much as possible. Her studio is equipped with a large bay window that often becomes her key light. She usually uses two softboxes (a 3x4- and a 5x7-foot model) depending on the type of lighting and the number of

people she is photographing. Taufer also uses large 40x70-inch Larson reflectors, especially the Soft Silver and Super Silver models. She does not use either a hair or background light, but is a big fan of painted-sky canvas backgrounds.

5. Indoor Lighting

*E*ven when working indoors on location shoots, you cannot always predict the conditions you'll find. You may have to work with what is there. Mixed lighting conditions, fluorescent tubes everywhere, no light to speak of, or harsh direct sunlight streaming

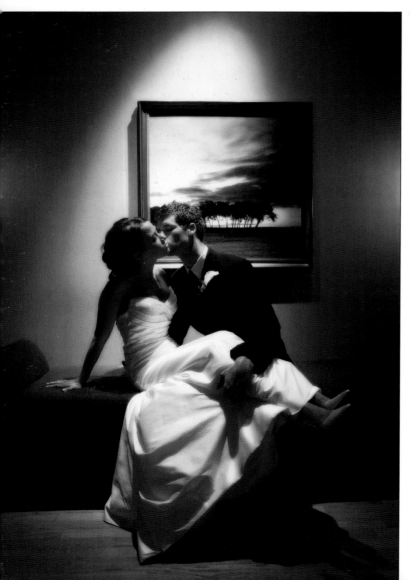

in open windows—these are all conditions you can (and will) find the minute you leave the friendly confines of the studio. However, being on location can be a challenge and a thrill, and some photographers have developed lighting systems that work as well as, if not better than studio lighting.

Continuous *vs.* Instantaneous Light Sources
It doesn't matter whether you choose continuous or instantaneous light sources; each has its advantages. Strobe lighting requires substantially less power to operate than continuous sources and puts out little or no heat. However, portable flash units have no modeling lights, making predictable results difficult—if not impossible. Even with studio flash, the built-in modeling lights may not offer a precise preview of what you'll get in your image. Continuous light sources, on the other hand, let you see

The can lighting found in many hotels and other public buildings is sharp and overhead. It is often used as an accent light to light walls or alcoves. Many photographers employ such available light, but the caveat is that the subject must look up toward the light to avoid the "raccoon eyes" look of overhead lighting. Kevin Jairaj made this image with a Canon EOS 5D and EF 20mm f/2.8 USM lens at ⅛ second at f/2.8 at ISO 640. Notice the bride looking up so that her face is well lit by the can light above.

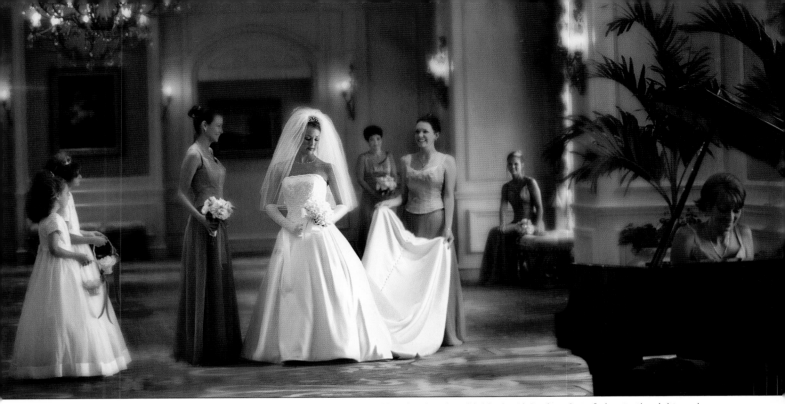

This is a remarkable mixed-light photograph of the bride and her bridesmaids taken in a hotel lobby by Al Gordon. Out of view to the right are long floor-to-ceiling windows that let in beautiful, soft light. One window, in particular, lit the area where the bride stood. The rest of the lighting is a mixture of room light from the lobby's candelabras and chandeliers. Even though the photographer had a softbox and strobe with him, he didn't need to use it because of the beautiful natural light.

exactly the effect you will get, since the light source is both the modeling light and the actual shooting light (just remember to use a tungsten-balanced film or adjust the white-balance setting to match the light source).

Lighting Group Portraits

A common location assignment involves photographing a group of people—a family reunion at the family home, executives in a boardroom, employees at a factory, etc.

Types of Lights. Umbrella lights are the best choice for lighting large groups. Usually, the umbrellas are positioned on either side of the camera, equidistant between the group and the camera so the light is even. The lights should be feathered so there is no hot center to the lighting. These units should also be slaved (with either radio or optical slaves) so that when the photographer triggers the main flash, all of the umbrellas will fire in sync. Monolight-type strobes work best for this type of application since they have a photo slave built in for just such situations.

Another means of lighting large groups is to bounce undiffused strobes off the ceiling to produce an overhead type of soft light. This light will produce an even overall

lighting but not necessarily the most flattering portrait light. You can, however, pair this light with a more powerful (by about one stop) umbrella flash at the camera. Placed slightly higher than the group and slightly to one side, this will produce a pleasant modeling effect. The bounce light then acts as fill, while the umbrella flash acts as the key light. Be sure to meter the fill and the key lights separately and expose for the key.

Quartz-halogen lights can be used similarly, although you must use tungsten-balanced film or choose a tungsten (or custom) white-balance setting for your digital camera. Hot lights provide the same flexibility as strobes—and perhaps even more, because you can see the light fall-off. When shooting, you can also use your in-camera meter for reliable results.

Even Lighting. Whether you're using quartz lights or strobes in umbrellas, it is imperative that the lighting is even across the group—left to right and front to back. Any deviation of more than ⅓ stop will be noticeable, particularly if shooting digital in the JPEG mode. It is a good idea, when you set the lights, to have an assistant meter the corners and center of the group to confirm that the lighting is even.

Light Positions. It is irrelevant to talk about portrait lighting patterns here (like Paramount, loop, and Rembrandt lighting). Instead, you should be concerned about getting the lights high enough to model the subjects' faces, and getting the light off to the side so that it is not a flat frontal lighting. But again, these aspects of the lighting are dictated by the size of the group and the area in which you must photograph them. What is important is that you create a one-light look, as you'd find in nature, with no double sets of shadows.

Feathering. If you aim a light source directly at your group, you will find that, while the strobe's modeling light might trick you into thinking the lighting is even, it is really falling off at the ends of the group. Feathering, aiming the light source past the group so that you use the edge of the light instead of the core, will help to light your group more evenly. Always check the results in the viewfinder and with a meter. If shooting digitally, fire a few test frames and review them on the camera's LCD.

Another trick is to move the light source back so that it is less intense overall, but covers a wider area. The light will be less diffused the farther you move it back.

LEFT—There is no more serious business at a wedding than the last-minute preparations by the bridesmaids and flower girls. Photographer Kevin Jairaj captured this priceless scene with window light only. The light is a bit contrasty, as the foursome was a good distance from the window. Curtains blocked the light from reaching the back of the room, making that area of the scene go dark. The image was made with a Canon EOS 5D and EF 70–200mm f/2.8L IS USM zoom lens at an exposure of $1/180$ second at f/2.8 at ISO 1250. BELOW—This is a group portrait that pushes the limits of the light. Bars are notorious for being dimly lit. Here, Kevin Jairaj photographed the bridal party using room light and bounce flash at an exposure of $1/30$ second at f/4 with a Canon EOS 5D and EF 16–35mm f/2.8L USM zoom lens at ISO 1250. He had to lower the base exposure to record the room lights, a technique known as "dragging the shutter." He chose f/4 rather than f/2.8, the lens's maximum aperture, to control some of the aberrations and sharpness problems that occur with fisheye lenses used wide open.

LEFT—Kevin Jairaj says the lighting is not tricky for this shot, but finding good lighting like this is. The image was shot in an outdoor hallway with light coming in from camera right. According to Kevin, "It was really dark in the hallway except for the nice light coming in. I used just a touch of fill-flash to get some sparkle in the eyes." The photo was shot in RAW mode with a Canon 20D and 70–200mm IS L lens at 130mm. The exposure was 1/20 second at f/2.8 at ISO 100. The shot is warm toned because Kevin used a "cloudy" white balance setting to warm the image.
RIGHT—Chris LaLonde calls this image *Blue Room*. It was taken at mid-morning using only diffused window light. The light was softened by the curtains and because of the time of day, it was almost entirely neutral in terms of color balance, creating exceptionally clean whites.

Focus. Since you will be using the lens at or near its widest aperture, it is important to focus carefully. Focus on the eyes and, if necessary, adjust members of the group forward or backward so they fall within the same focal plane. Depth of field is minimal at these apertures, so control the pose, focus as carefully as possible, and be sure light falls evenly on all the faces.

Window Light

Advantages. One of the most flattering types of lighting you can use is window lighting. It is a soft light that minimizes facial imperfections, but it is also a highly directional light, yielding good roundness and modeling in portraits. Window light is usually a fairly bright light and it is infinitely variable, changing almost by the minute. This allows for a great variety of moods in a single shooting session.

Challenges. Window lighting also has several significant drawbacks, though. Since daylight falls off rapidly once it enters a window, it is much weaker several feet from the window than it is close to the window. Therefore, great care must be taken in determining exposure—particularly with groups of three or four people. Another problem arises from shooting in buildings that are not designed for photography; you will sometimes encounter distracting backgrounds and uncomfortably close shooting distances.

Direction and Time of Day. The best quality of window light is found at mid-morning or mid-afternoon. Direct sunlight is difficult to work with because of its intensity and because it often creates shadows of the individual windowpanes on the subject. It is often said that north light is the best for window-lit portraits, but this is

not necessarily true. Good quality light can be had from a window facing any direction, provided the light is soft.

Subject Placement. One of the most difficult aspects of shooting window-light portraits is positioning your subjects so that there is good facial modeling. If the subjects are placed parallel to the window, you will get a form of split lighting that can be harsh and may not be right for certain faces. It is best to position your subjects away from the window slightly so that they can look back toward it. In this position, the lighting will highlight more areas of the faces.

The closer to the window your subjects are, the harsher the lighting will be. The light becomes more diffused the farther you move from the window, as the light mixes with other reflected light in the room. Usually, it is best to position the subjects about three to five feet

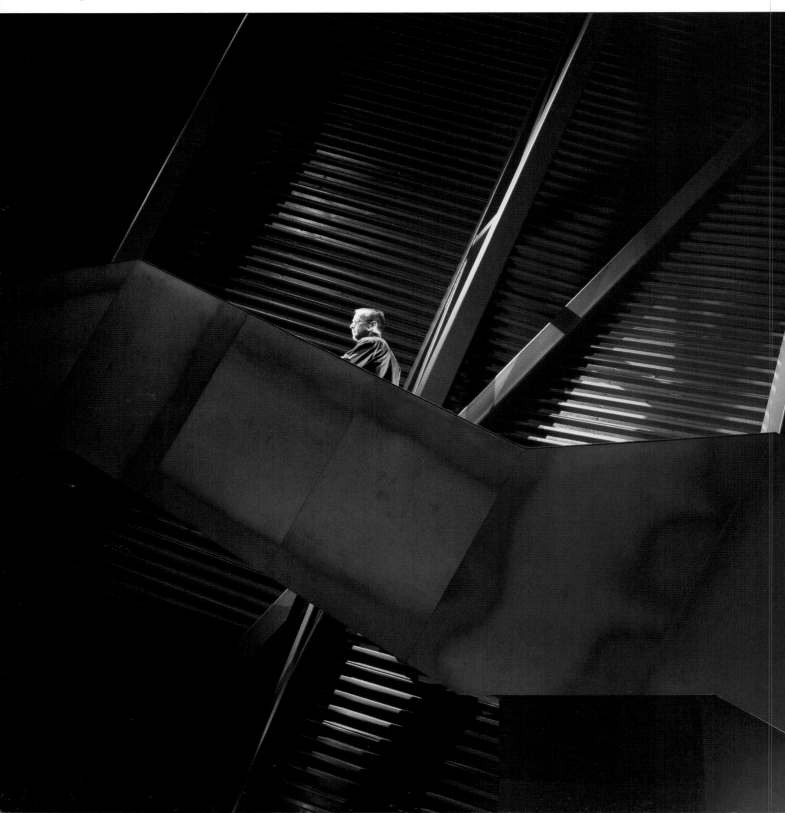

from a large window. This not only gives better lighting, but also gives you a little room to produce a flattering pose and pleasing composition.

Metering. The best way to meter for exposure is with a handheld incident meter. Hold it in front of each subject's face, in the same light as the subject, and take a reading with the light-sensitive hemisphere pointed directly at the camera lens.

With more than one subject you'll get multiple readings. Choose an exposure midway between the two or three readings. Whatever direction the faces are turned (*i.e.*, toward the window or toward the camera), make the meter's hemisphere mimic the same angle for a more accurate reading.

If using a reflected meter, like the in-camera meter, move in close and take readings off the faces. If the sub-

Chris LaLonde shot this image for the cover of an annual report. All the images he did of the company employees and directors were done with the same theme in mind: stairs and their representation of growth. Chris shot seven different locations with various styles of stairs, photographing from one to seven people at a time. This location, the Canadian War Museum, was ideal because of its grand spaces. Everything is very dark—blacks, grays, browns—so a lot of light was required. According to Chris, "I hate to have to look for power sources on location, so all of the images were done with Lumedyne packs and Nikon SB 800 Speedlight flash heads. I always carry about seven Nikon heads with me and I needed all of them in this shot." He also used Lightshaper modifiers, a great tool for changing the shape of the light coming from a softbox. Basically, the Lightshaper consists of four panels that velcro onto the front panel of a softbox. He says, "Because I wanted to keep the image very dark, I shrunk the box down to a quarter of its original 24x36-inch size, creating a tight light on the face and upper body. This stopped most of the spill from hitting the background. The rest of the area was illuminated with SB 800 Speedlight flash heads modified with black foil that I taped to the front of the light to control the shape of the source." Pocket Wizards were used to fire all of the strobes in sync. The image was shot with a Nikon D2X and Sigma 18–50mm f/2.8 lens for 1/20 second at f/6.3.

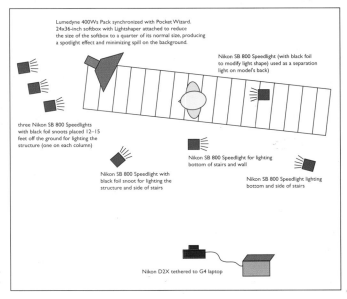

Lumedyne 400Ws Pack synchronized with Pocket Wizard. 24x36-inch softbox with Lightshaper attached to reduce the size of the softbox to a quarter of its normal size, producing a spotlight effect and minimizing spill on the background.

Nikon SB 800 Speedlight (with black foil to modify light shape) used as a separation light on model's back)

three Nikon SB 800 Speedlights with black foil snoots placed 12–15 feet off the ground for lighting the structure (one on each column)

Nikon SB 800 Speedlight for lighting bottom of stairs and wall

Nikon SB 800 Speedlight with black foil snoot for lighting the structure and side of stairs

Nikon SB 800 Speedlight lighting bottom and side of stairs

Nikon D2X tethered to G4 laptop

jects are particularly fair-skinned, remember to open up at least one f-stop from the indicated reading. Most camera light meters take an average reading, so if you move in close on a person with an average skin tone, the meter will read the face, hair, and what little clothing and background it can see and give you a fairly good exposure reading. Average these readings and choose an intermediate exposure setting.

White Balance. If shooting digitally, a custom white-balance reading should be taken, since most window-light situations will be mixed light (daylight and room light). If working in changing light, take a new custom white-balance reading every twenty minutes or so to ensure that the changing light does not affect the color balance of your scene. Alternatively, shoot in RAW capture mode, which will allow you to fine-tune the color balance after capture.

Fill Light. *Fill Cards.* The easiest way to fill the shadows is with a large white or silver fill reflector placed next to the subjects on the side opposite the window, angled up to catch incoming light and reflect it back on the group. Setting the proper angle takes some practice and is best handled by an assistant so that you can observe the effects in the viewfinder.

Room Lights. If a fill card is not sufficient, it may be necessary to provide another source of illumination to achieve good balance. Sometimes, flicking on a few room lights will produce good overall fill-in by raising the am-

bient light level. If you do this, however, be sure the lights do not overpower the window light, creating multiple lighting patterns. Keep in mind that you will get a

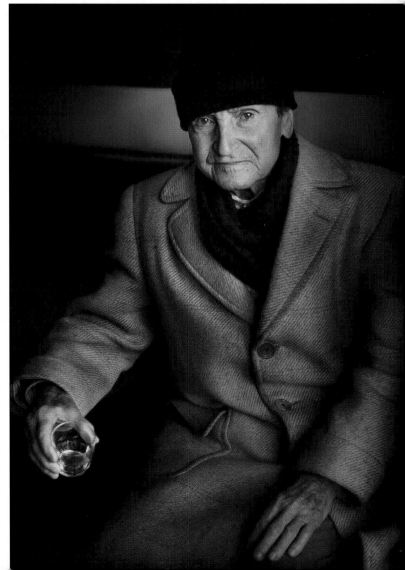

FACING PAGE—Soft light coming from a large window was the main light source for this image, and the source of the white-balance setting. The secondary light source was room light. You can see how much the window light falls off in intensity between the dancer to the right and the one to the left. The image was completely redone in Painter, leaving only the faces relatively untouched. Photograph by Bruce Dorn. TOP RIGHT—Kevin Jairaj made this stunning engagement portrait using a large window to camera left. There were no reflectors or flash used in the shot, however, you can see (if you look closely at the catchlights in their eyes) the reflection of sunlight striking the floor in front of the couple, which acted as a large fill source. The image was made with a Canon EOS 10D camera and 70–200mm IS L lens (at 70mm) at an exposure of 1/60 second at f/2.8 at ISO 160. BOTTOM RIGHT—This is another window-light portrait made by Anthony Cava of a friend named Zizi, who lived near Cava's Ottawa studio. The light source is a very large window at almost a right angle to the man. Anthony vignetted the image in Photoshop so that the lightest parts of the portrait are his face and the shot glass.

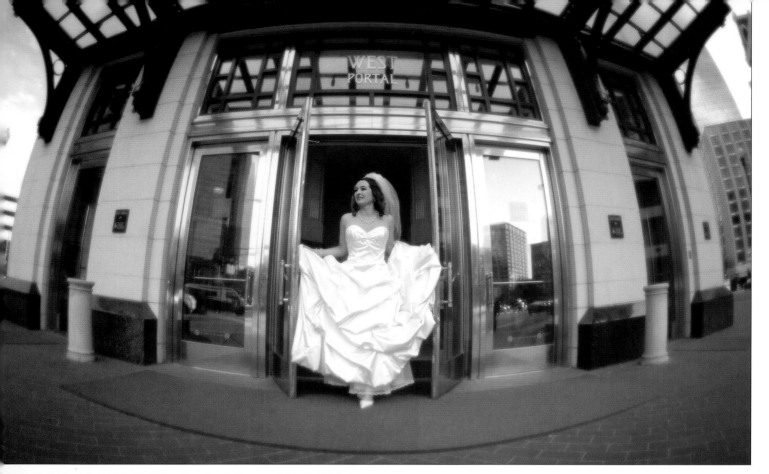

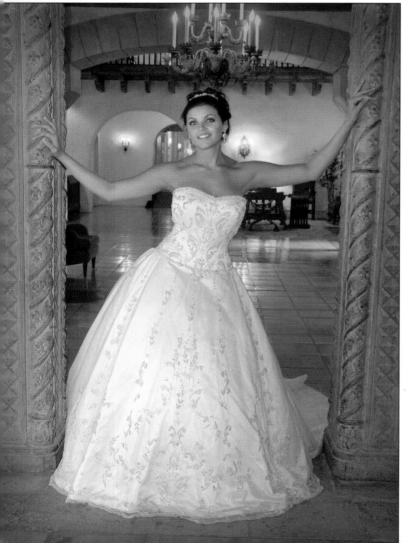

ABOVE—DeEtte Sallee noticed that the frosted glass awning above the entranceway to this hotel diffused the direct afternoon sunlight, creating a beautiful overhead softbox during the middle of the day. DeEtte moved in close with a Nikon D100 and 10.5mm f/2.8G ED AF DX Fisheye-Nikkor lens and exposed the scene for $^1/_{750}$ second at f/2.8. **LEFT—** Jeff Kolodny combined at least three different light sources in the scene to make a beautiful bridal formal. The doorway was lit by dim daylight with a blue tinge, and the room light was a combination of chandeliers and other lights. Jeff also popped a flash from the camera position at less intensity than the daylight to help warm up the color balance and give a sparkle to the bride's eyes.

warm glow from the tungsten room lights if you are using daylight-balanced film or a daylight white-balance setting. This is quite pleasing if it's not too intense.

It is also a good idea to have a room light in the background behind the subjects. This opens up an otherwise dark background and provides better depth in the portrait. If possible, position the background room light behind the subject, out of view of the camera, or off to the side, out of the camera's field of view so it lights the wall behind the subjects.

Bounce Flash. If none of the above methods of fill-in is available to you, use bounce flash. You can bounce the light from a portable electronic flash off a white card, the

ceiling, an umbrella, or a far wall—but be sure that it is ½ to one f-stop less intense than the daylight. When using flash for fill-in, it is important to carry a flashmeter to determine the intensity of the flash.

Diffusing Window Light. If you find a nice location for a portrait but the light coming through the windows is direct sunlight, you can diffuse it by taping acetate diffusing material to the window frame. This produces a warm, golden window light. Light diffused in this manner has the feeling of warm sunlight but without the harsh shadows. If it's still too harsh, try doubling the thickness of the acetate for more diffusion. Since the light is so scattered by the scrim (the term for these diffusers in the movie industry), you will probably not need a fill

source. Even without fill, it is not unusual to have a low lighting ratio in the 2:1 to 2.5:1 range. The exception is when you are working with a larger group. In that case, use reflectors to bounce light back into the faces of those farthest from the window.

Scrims are sold commercially and come in large sizes up to 8x4 feet or so. Like portable reflectors, these scrims are supported on a flexible frame that folds down to about a quarter of the scrim's extended size. When extended, they are rigid and will fit nicely inside a large window frame.

Mastering One Light

If you want to improve your location-portrait lighting techniques drastically in a relatively short time, learn to use one light to do the job of many. One light can effectively model the features of a single subject or small group with relative ease. Whether you own strobe, portable, or studio-flash equipment, tungsten or quartz-

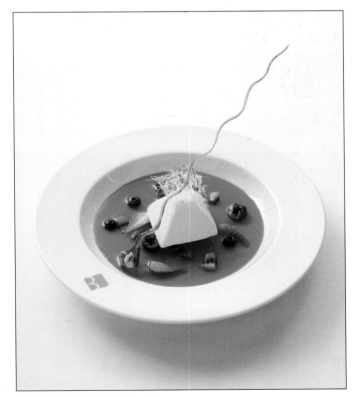

LEFT—Jeff Kolodny makes it a point to photograph the decorations prior to the guests arriving at the reception. This beautiful scene was lit by daylight, ambient room light, and candlelight. His tripod-mounted D200 and 35mm lens was stopped down to f/29 and the exposure was made at 30 seconds. The white balance was set at 2850K for the right blend of warmth. **RIGHT**—Chris LaLonde photographed this beautiful raspberry dessert with diffused window light and small beauty mirrors. An 8-foot-high window, which acted as the key light, was lined with diffusion acetate to soften the light. The mirrors were used to aim direct light back into the dessert to produce specular highlights. The photo was made with a Kodak DCSn digital camera and 50mm f/1.4 lens. The film speed was ISO 160 and the exposure was ¹/₁₂₅ at f/4.

halogen lighting equipment, you will get your money's worth from it by learning to use one light well. You will also better understand lighting and learn to "see" good lighting by mastering a single light.

Handheld Video Lights. Photographer David Williams uses small handheld video lights to augment existing light at a wedding or on location. He glues a Cokin filter holder to the front of the light and places a medium blue filter (a 025 Cokin) in the holder. The filter brings the white balance back from tungsten to about 4500K,

FACING PAGE—Chris Nelson made this striking close-up portrait with a softbox as a main light. A reflector was used to camera right, and an umbrella was used above the camera, aimed straight in at the model but feathered upward slightly to put more light on her red hair than her white sweater. The umbrella was set to output one stop less light than the main light. A strip light was used as the hair light. This was positioned above and behind the subject and set at the same output as main light. Crumpled gold Mylar was used as a background. LEFT—Marcus Bell made this memorable image of the bride descending a circular staircase by pushing the limits of the available light. A very slow shutter speed of $1/15$ second was required to record the three levels of the photograph. A bounce flash at the top of the stairwell, where Bell was located with a very wide-angle lens, put just enough light on the bride to make her the focal point of the composition. BELOW—In a darkened pub, Australian wedding specialist Yervant used a handheld video light (held by an assistant) to light this dazzling portrait. The secret was balancing the room lights with the video light, which was pretty easy to do by decreasing the power of the video light or feathering it.

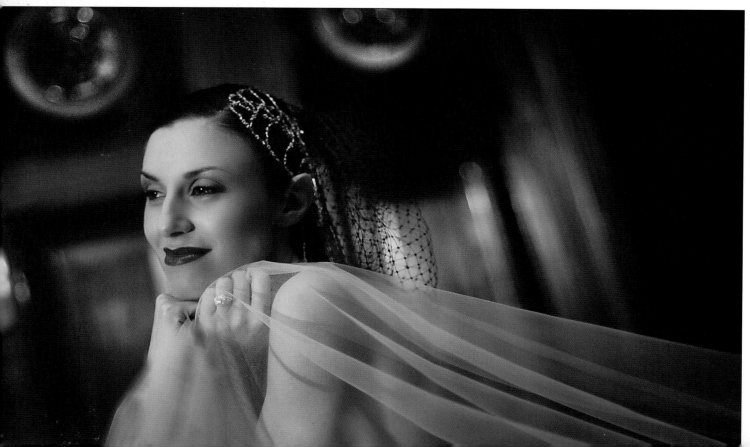

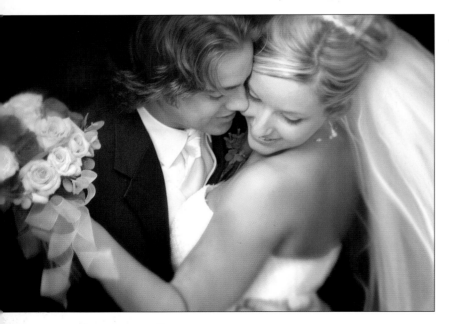

which is still slightly warmer than daylight. It is the perfect warm fill light. If you want an even warmer effect, or if you are shooting indoors with tungsten lights, you can simply remove the filter.

These lights sometimes have variable power settings. Used close to the subject (within ten feet) they are fairly bright, but can be bounced or feathered to cut the intensity. David uses them when shooting wide open, so they are usually just employed for fill or accent.

The video light can also be used to provide what David calls, a "kiss of light." He holds the light above and to the side of the subject and feathers it back and forth while looking through the viewfinder. The idea is to produce just a little warmth and light on a backlit object or something that is lit nondescriptly.

Sometimes he uses an assistant to hold two lights, each canceling out the shadows from the other. He often combines these in a flash-bracket with a handle. His video light has a palm grip attached to the bottom to make it more maneuverable when he has the camera in the other hand.

Diffused "Straight" Flash. On-camera flash should be avoided for making portraits, unless it is used as a fill-in source. Its light is too harsh and flat and it produces no roundness or contouring of the faces. However, when you diffuse on-camera flash, you get a softer frontal lighting, similar to fashion lighting (see sidebar on page 92). While diffused flash is still a flat lighting and frontal in nature, its softness produces much better contouring than direct, undiffused flash.

Sometimes straight flash is the only effective way to make an exposure. Photographer Cliff Mautner used a very slow shutter speed and panned the camera in the dim light to blur the background lights. The on-camera flash fired at the instant of hilarity, creating a priceless image.

There are various devices on the market for diffusing on-camera flash. Most can even be used with your flash in auto or TTL mode, making exposure calculation effortless. Nikon offers retractable diffusion panels for its high-end SB Speedlights that provide full TTL operation with the diffuser in place.

Bounce Flash. Portable electronic flash is the most difficult of one-light applications. Because portable flash units do not have modeling lights, it is impossible to preview the lighting effect you will achieve. Still, when it is bounced off the ceiling or a side wall, portable flash produces efficient wraparound lighting that illuminates portrait subjects beautifully. The key is to aim the flash unit at a point on the wall or ceiling that will produce the widest beam of light reflecting back onto your subjects. Also, keep in mind that you should never bounce flash off colored walls or ceilings. The light reflected back onto your subjects will be the same color as the walls or

ceiling and it will be almost impossible to correct, whether you're shooting film or digital.

Bounce-Flash Accessories. Many photographers use their on-camera flash in bounce-flash mode. A problem, however, with bounce flash is that it produces an overhead soft light. With high ceilings, the problem is even worse; the light source, while soft, is almost directly overhead. There are a number of devices on the market, like the Lumiquest ProMax system, that allow most of the flash's illumination to bounce off the ceiling while some is redirected forward as fill light. This solves the overhead problem of bounce flash. The Lumiquest system also includes interchangeable white, gold, and silver inserts as well as a removable frosted diffusion screen.

Lumiquest also offers devices like the Pocket Bouncer, which enlarges and redirects light at a 90-degree angle from the flash to soften the quality of light and distribute it over a wider area. While no exposure

ON-AXIS FASHION LIGHTING

Fashion lighting is a variation of conventional portrait lighting. It is extremely soft and frontal in nature—in fact, the key light is usually on the lens–subject axis. Because the key light produces almost no shadows, makeup is frequently used to produce contouring. It is a stark lighting that is usually accomplished with a large softbox directly over the camera and a silver reflector just beneath the camera. Both the light and reflector are very close to the subject for the softest effect.

When you examine the catchlights in a fashion portrait you will see two—a larger one over the pupil and a less intense one under the pupil. Occasionally, you will see a circular catchlight produced by a ringlight flash—a macrophotography light that mounts around the lens for completely shadowless lighting.

A conventional softbox on its own light stand will not work for this type of lighting because the stand gets in the way. Usually a softbox that is mounted to a boom arm, which is counterweighted for balance, is the way to go. A silver reflector is often used beneath the camera lens and angled up at the face. The result is a wide beam of frontal light that minimizes texture.

When it comes to male fashion portraiture the trend is quite different—you want a bold, dramatic, masculine look. Flat lighting is seldom used with men. Side lighting with bold shadows and very little fill is currently popular.

The camera was positioned directly in front of a softbox for a ringlight effect. Two Nikon SB 80 strobes illuminated the background to pull a clean white. Exposure was critical to maintain detail throughout the white tones and jewelry. Image by Anthony Cava.

compensation is necessary with TTL flash exposure systems, operating distances are somewhat reduced. With both systems, light loss is approximately 1⅓ stops; with the ProMax system, however, using the gold or silver inserts will lower the light loss to approximately ⅔ stop.

Bounce Flash Exposure. If shooting digital, you can test the flash exposure and examine the results on the camera's LCD monitor. Also, since many of the pro DSLR manufacturers also incorporate TTL flash systems, even in bounce mode, the system will provide amazingly accurate exposures. Some flash units allow the flash head to swivel in any direction, while the flash sensor (which is actually inside the camera at the film plane in TTL systems) remains pointed at the subject. Again, you can make a test exposure and examine the LCD.

Multiple Lights

Remote Triggering Devices. If using multiple flash units, some type of remote triggering device will be needed to sync all the flash units at the instant of exposure. There are a variety of these devices available; by far the most reliable, however, is the radio-remote triggering device. When you press the shutter release, it transmits a radio signal (either digital or analog) that is received by individual receivers mounted to each flash. Digital systems, like the Pocket Wizard Plus, are state of the art. Complex 16-bit digitally coded radio signals deliver a unique code, ensuring the receiver cannot be triggered or "locked up" by other radio noise. The built-in microprocessor guarantees consistent sync speeds even under the worst conditions. Some photographers use a separate transmitter for each camera, as well as a separate one for the handheld flashmeter, allowing the photographer to take remote flash readings from anywhere in the room.

Extending Depth of Field

Many location-photography subjects require extended depth of field. Room interiors that call for both near and distant subjects to be in focus require long exposures with small apertures (if using continuous lighting) or multiple strobe pops (if shooting with strobes). Some tabletop products also require extended depth of field and will often demand the smallest lens apertures you have available. There are several problems with using either long exposures or multiple strobe pops.

RIGHT—This group portrait is actually a montage made up of three individual shots stitched together in Photoshop. The head chef and bottom row is one image; the middle and top rows are separate images. All three images were made with all natural light plus a 600Ws White Lightning bounced into a 4x8-foot white Fome-Cor board. The strobe was kept two stops less than the main exposure of f/5.6 just to add evenness and fill-in. All shots were done with a Kodak SLR/n and 50mm f/1.4 lens and captured directly to a G4 laptop. Photograph by Christian LaLonde. **BELOW**—Scott Eklund created this terrific action shot of a boxer in training by combining the diffused daylight of the gym with rear-curtain sync flash. The interior exposure was fairly dim and Eklund used a medium aperture so that there would be plenty of blurring in the ambient-light exposure. The flash, positioned above and to the right of the boxer was set to rear-curtain sync mode so that the flash would fire at the end of the long exposure, creating speed blurs behind the flash exposure for a dramatic effect.

David Wendt traveled to Dallas to photograph this rare (only three were built) 1965 Ferrari 275 GTB/C in front of a massive English-style manor. Although the shot appears to have been taken early in the morning, it was really made at noon on a sunny day. Wendt took nine exposures, which were later sandwiched in Photoshop to produce the final image. Using a Canon EOS 1DS and 50mm lens set at f/22 mounted to a sturdy tripod, Wendt "painted" the car eight times with a 400Ws Lumedyne flash unit, firing his flash at different parts of the car from various distances to adequately illuminate the vehicle and give it a dramatic shape. He used a Pocket Wizard to trip the shutter, which was set to the fastest sync speed of $\frac{1}{250}$ second. Wendt downloaded the nine images and then, in Photoshop, dragged each of the separate layers over the previous layer, which resulted in a sandwich of nine different lighting layers. After the sandwich was complete David realized he had missed lighting a few spots on the front fender of the coupe. He retouched those spots by creating new layers and then sampling existing colors and painting them onto the car.

Reciprocity Failure. All exposures are equal to one another except when the exposure times are very short or very long. While $\frac{1}{15}$ second at f/8 may be equal to $\frac{1}{30}$ second at f/5.6 and produce the identical results, one second at f/32 (which is the equivalent exposure) may not produce the same results because of reciprocity failure, characterized by light loss and change of color balance. Film data sheets contain detailed information on correcting this by further lengthening the exposure and adding color correction filters. All films are somewhat different and there are no generalized instructions that can be offered except to bracket toward overexposure when you encounter an exposure time longer than 1 second. Similarly, very short exposures, such as $\frac{1}{8,000}$ second, can also create reciprocity problems. Again, see the film data sheet for detailed information. As a rule of thumb, though, if exposures are in this neighborhood, bracket toward overexposure to be on the safe side. *Note:* Reciprocity failure does not affect digital cameras, although long exposure times will produce excess noise.

Multiple Strobe Pops. Suppose you are shooting an interior where nothing is moving, and your strobes are set for maximum light output yet only produce an f/11 output. In reviewing the scene with the depth-of-field preview or LCD, you determine you need an aperture of f/22 to get all aspects of the scene sharp. The solution is

to open the camera shutter to B (bulb setting), extinguish the modeling lights, and produce multiple strobe pops to bring the accumulated exposure to f/22.

"How many," you ask? To double the amount of light (taking you from f/11 to f/16) you would pop the strobes one additional time for a total of two pops. To double the amount of light again, you would hit the open flash button four more times (a total of six pops). That will produce an f/22 exposure. You have effectively doubled the light output twice. Conveniently, most digital incident flashmeters have a "multiple" channel that lets you test the number of flash pops it will take to achieve a certain aperture. As you pop the strobes with the meter, the f-stop reading will change and it will keep track of the number of individual flash pops.

There are several things you need to keep in mind. First, you will be working in the dark (modeling lights have been extinguished), so be sure your meter is in its illuminated mode so you can read the data. Second, wait until you see the power pack's recycle light glowing before you fire subsequent pops. If the flash is not fully recycled, it may not pop at full power, which will negate the results of your careful testing. Third (and this is the one that most photographers forget about), close the shutter! If it's open and if you turn on the lights before closing the shutter, you will be recording information on the film or chip.

Painting With Light

Painting with light is not new. As when using multiple strobe pops to illuminate a still life or interior, this type of photography is done with the shutter open and all other lights extinguished. The difference is that the light is now going to move around the subject.

The flashlight of preference for painting with light seems to be the Mag-Lite, which offers products that range from 1,200 to 40,000 candlepower (candelas). Another handy light-painting tool is the light stick, a small, portable electronic flash tube that can be manipulated into hard to light areas. You can also combine the flashlight effects with an overall strobe exposure to produce two different color renditions on the same frame.

The scene can be painted from one angle or many, but it is probably a good idea to emulate the one-light concept. For instance, move the flashlight all around the

product but only from above. Resist the temptation to fill every crevice with light. You will end up with a completely flat look that offers no dimension. You must also be careful not to point the light source at the camera, as it will record as a specular highlight. Further, be sure not to light yourself with the flashlight or strobe. If you do, you will show up as a ghost image in the frame.

Experimentation is the best teacher. Also, having the DSLR's LCD for reference will allow you to determine if your painting techniques are working.

Chris LaLonde handpainted this antique stamp in three different steps. The first step was pulling the focus forward (knocking the stamp out of focus) and exposing for the background with a 600Ws White Lightning strobe (½ second at f/5.6). Then, after readjusting the focus, he exposed the stamp with an overhead softbox using the tungsten modeling light only in the softbox (about 2 seconds at f/5.6). Lastly, he exposed the stamp for 15 seconds at f/5.6 with a mini flashlight. He painted around the perimeter of the stamp by moving the flashlight over it in a painting stroke. The tungsten flashlight produced a yellow glow on the stamp and the pulled focus of the first step created a black outline around the stamp.

6. Outdoor Lighting

Nature provides every lighting variation imaginable. That's why so many images are made with it. Often, the light is so good that there is just no improving on it. For example, I used to work for a major West Coast publishing company that specialized in auto- motive publications. One of the studios that was used for photographing cars was massive, with a ceiling that was between three and four stories high. Below the ceiling was a giant scrim suspended on cables so that each of the four corners could be lowered or raised. Huge banks of incandescent lights (twelve and sixteen lights to a bank) were bounced into the scrim to produce a huge milky-white highlight the length of the car—a trademark of automotive photography. The studio was used when a car could not be photographed outside in public or when it was only on loan to the magazine (*Motor Trend*) for a very short time. Despite the availability of this space, if time and the weather were on their side, the staff photographers would invariably opt to photograph the car

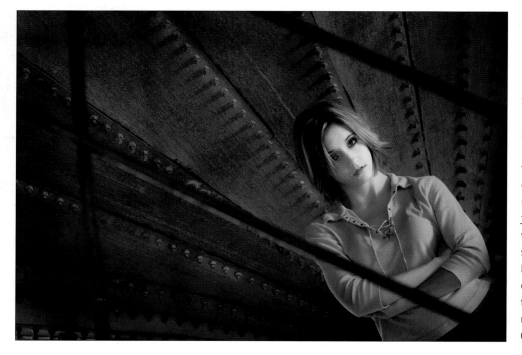

This senior portrait was shot on location outside under a grain bin used for soybeans. The image was taken on the shadow side of the grain bin. No direct sunlight was used. A 72-inch silver reflector was placed to the right of subject, about thirty feet away, to redirect the sunlight onto the subject's face. A second small reflector was placed just to the left side of the subject, outside of the frame, to brighten up the shadows. Notice the delicate edge light that the second reflector created along the subject's right arm and shoulder. Photograph by Craig Kienast.

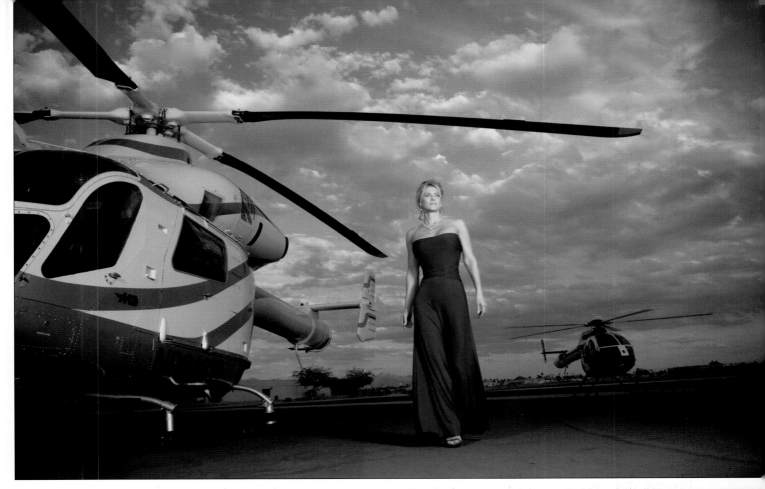

TOP—Cherie Steinberg Coté created this wonderful high-fashion image with a Dyna-Lite Jackrabbit kit, which includes two strobe heads and portable rechargeable batteries. Cherie says, "We were lucky to get these shots. It was sunset and the sky was perfect. With the two Dyna-Lite strobes, we popped the model. The second flash was feathering the helicopter." RIGHT—Learning to see light is a skill that good photographers acquire over time. In this beautiful image by Jeffrey and Julia Woods, the light was diffused backlight from a late afternoon sun with scattered overcast. The Woods positioned the couple so that the groom's face received the reflected light from the bride and her white dress, both natural reflectors. The lighting ratio is a beautiful a 2.5:1. The image was made with a Canon EOS 1D Mark II and 70–200mm f/2.8 lens at 200mm. The film speed was ISO 160 and the exposure was $\frac{1}{1,000}$ second at f/3.2.

at twilight, when the setting sun, minutes after sunset, created a massive skylight in the Western sky. No matter how big or well equipped the studio, nature's light is far superior in both quantity and quality.

Finding the Right Light

Shade. In order to harness the power of natural light, one must be aware of its various personalities. Unlike the studio, where you can set the lights to obtain any effect you want, in nature you must use the light that you find

or alter it to suit your needs. By far the best place to make outdoor images is in the shade, away from direct sunlight.

Shade is nothing more than diffused sunlight. Contrary to popular belief, shade is not directionless. It has a very definite direction. The best shade for any photographic subject, but primarily for people, is found in or

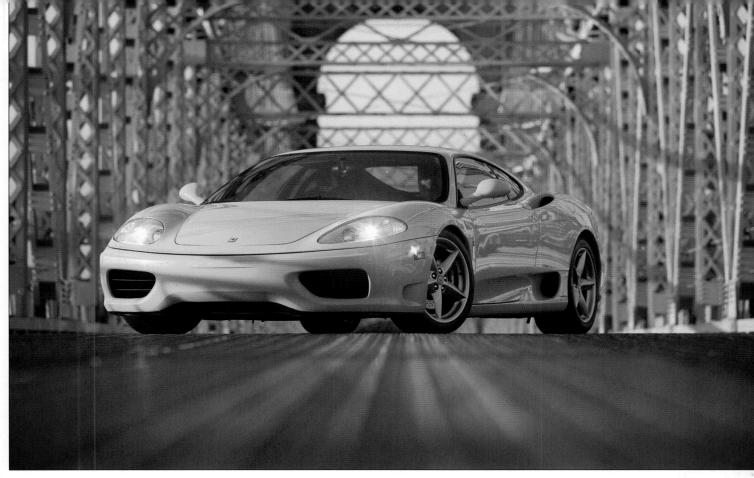

ABOVE—David Wendt makes beauty shots of classic cars and publishes his own calendars. The secret to this shot is color contrast. Not only do yellow and blue oppose each other on the color wheel for the greatest contrast, but the textures also contrast. The bridge and road surface are rough and the car smooth. This image was made right after sunrise at 6:45AM on a Sunday. According to Dave, "Nobody was out driving on this bridge except for an occasional bus." The light was a combination of skylight and early morning rays of sunshine. The bridge's texture was reflected into the long highlights of the car, which by the way, is a Ferrari 360. The image was made with a Canon EOS 1Ds Mark II and EF 70–200mm f/4L USM at 150mm. The exposure was $1/400$ second at f/4.5 at ISO 100. The image was shot in RAW mode and processed in Photoshop CS2. FACING PAGE—Fuzzy Duenkel is a master at twisting and bending shade, transforming it into golden, soft, sculpting light. He uses a number of large, highly efficient reflectors to redirect the shade and create a flattering lighting pattern. Here a large, gold-foil reflector was positioned close to the left side of the subject, which became the highlight side of her face. The shadow side was filled with smaller reflectors beneath the camera's view. Fuzzy also blended the highlights and shadows of the image in Photoshop.

near a clearing in the woods. Where the trees provide an overhang above the subjects, the light is blocked. From the clearing, diffused light filters in from the sides, producing better modeling on the face than in open shade. (Open shade is overhead in nature and most unflattering. Like noontime sun, it leaves deep shadows in the eye sockets and under the nose and chin of the subjects. If forced to shoot in open shade, you must fill-in the daylight with a frontal flash or reflector.)

Another popular misconception about shade is that it is always a soft type of lighting. Particularly on overcast days, shade can be harsh, producing bright highlights and deep shadows, especially around midday. Instead, move under an overhang, such as a tree with low-

hanging branches or a covered porch, and you will immediately notice that the light is less harsh and that it also has good direction. The quality of light will also be less overhead in nature, coming from the side that is not obscured by the overhang.

Working at Midday. For award-winning senior photographer Jeff Smith, working at midday has become an economic necessity. The best outdoor locations are thirty to forty minutes from his studio; to make it profitable to drive that far for a senior session, he schedules multiple sessions at the same location. He cannot afford the luxury of working only in the early morning or late afternoon when the light is best, so he schedules these appointments throughout the day.

Jeff Smith does not find it difficult to work at midday. For example, in this image he found a nice clearing, just on the edge of a sunlit meadow in the middle of the day. He used the shade as his base exposure, then employed a medium-sized softbox as the main light.

Smith works in shade exclusively. He tries to find locations where the background has sunlight on dark foliage and where the difference between the background exposure and the subject exposure is not too great. At the subject position, he first looks for lighting direction. He always tries to find an area where there is something that is blocking the light from the open sky overhead—a tree branch, the roof of a porch, or a black reflector (which he brings along for such situations). If there is no lighting ratio on the face, he creates one using a black gobo on the shadow side of the face for a subtractive lighting effect (see pages 105–7).

Once Jeff has the basic lighting the way he wants it, he adds a reflector underneath the subject, bringing out more eye color and smoothing the complexion, which is a must for seniors. He uses 72-inch Photoflex gold and white reflectors. He loops the handle of the reflector over a knob on his tripod and lets the bottom rest on the ground. This is the perfect angle for bouncing daylight up and into the face of his subject. In bright situations, he uses the white reflector to avoid overpower the natural light. In very soft light, he uses the gold reflector.

Low-Angle Sunlight. If the sun is low in the sky, you can use cross-lighting (split lighting) to get good mod-

eling on your subject. Almost half of the face will be in shadow while the other half is highlighted. Turn your subject into the light so as not to create deep shadows along laugh lines and in eye sockets. If photographing a group, you must also position your subjects so that one person's head doesn't block the light of the person next to him or her.

There must be adequate fill-in from the shadow side of camera so that the shadows don't go dead. If using flash fill (see pages 107–12 for more on this) try to keep your flash output equal to or about a stop less than your daylight exposure. If using reflectors, you can bounce the direct sunlight back into the shadow side of the face(s) by carefully aiming the reflector.

It is also important to check the background while composing a portrait in direct sunlight. Since there is considerably more light than in a portrait made in the shade, the tendency is to use an average shutter speed like $\frac{1}{250}$ second with a smaller-than-usual aperture like f/11. Small apertures will sharpen the background and distract from your subject. Preview the depth of field to analyze the background. Use a faster shutter speed and wider lens aperture to minimize background effects in these situations. The faster shutter speeds may also negate the use of flash, so have reflectors at the ready.

After Sunset. As many of the great photographs in this book illustrate, the best time of day for making great pictures is just after the sun has set. At this time, the sky

Martin Schembri made this image in the middle of winter with about five minutes of natural light left in the day. The session was shot in a city plaza, which had lots of tinted glass walls surrounding the location. To help fill in the shadows, the bride was positioned up against one of these walls and a reflector was used to help push some light in under the eyes. The main light was actually coming in from behind the groom's left shoulder and Martin managed to keep the fill ratios at around 1:1. The image was shot digitally using a Nikon D100 and 80–200mm zoom lens.

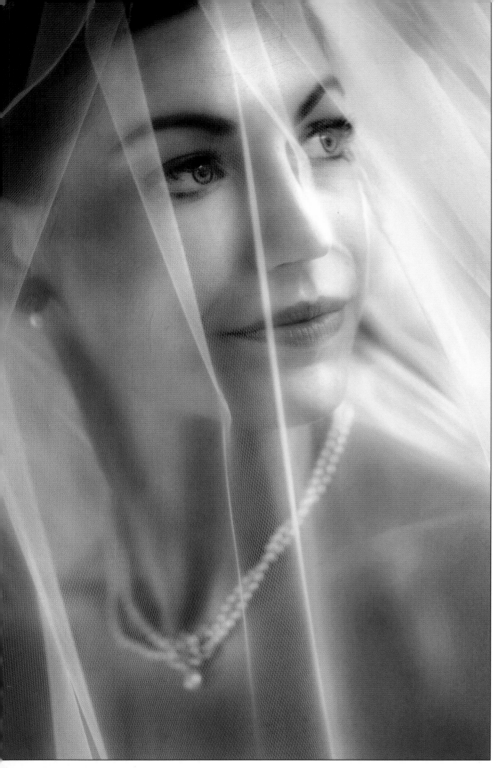

The second problem in working with this light is that twilight does not produce catchlights—white specular highlights in the eyes of the subjects. For this reason, most photographers augment the twilight with flash, either barebulb or softbox-mounted, to provide a twinkle in the eye. The flash can be up to two stops less in intensity than the skylight and still produce good eye fill-in and bright catchlights.

Reflectors

You are at the mercy of nature when you are looking for a lighting location. Sometimes it is difficult to find the right type of light for your needs. Therefore, it is a good idea to carry along a portable light reflector. The size of the reflector should be fairly large; the larger it is, the more effective it will be. Portable Lite Discs, which are reflectors made of fabric mounted on a flexible and collapsible circular or rectangular frame, come in a variety of diameters and are a very effective source of fill-in illumination. They are available from a number of manufacturers and come in silver (for maximum fill output), white, gold foil (for a warming fill light), and black (for subtractive effects).

becomes a huge softbox and the effect of the lighting is soft and even, with no harsh shadows.

There are two problems with working with this great light. First, it's dim. You will need a medium to fast ISO combined with slow shutter speeds, which can be problematic if there are children being posed. Working in subdued light also restricts your depth of field by virtue of having to choose wider apertures.

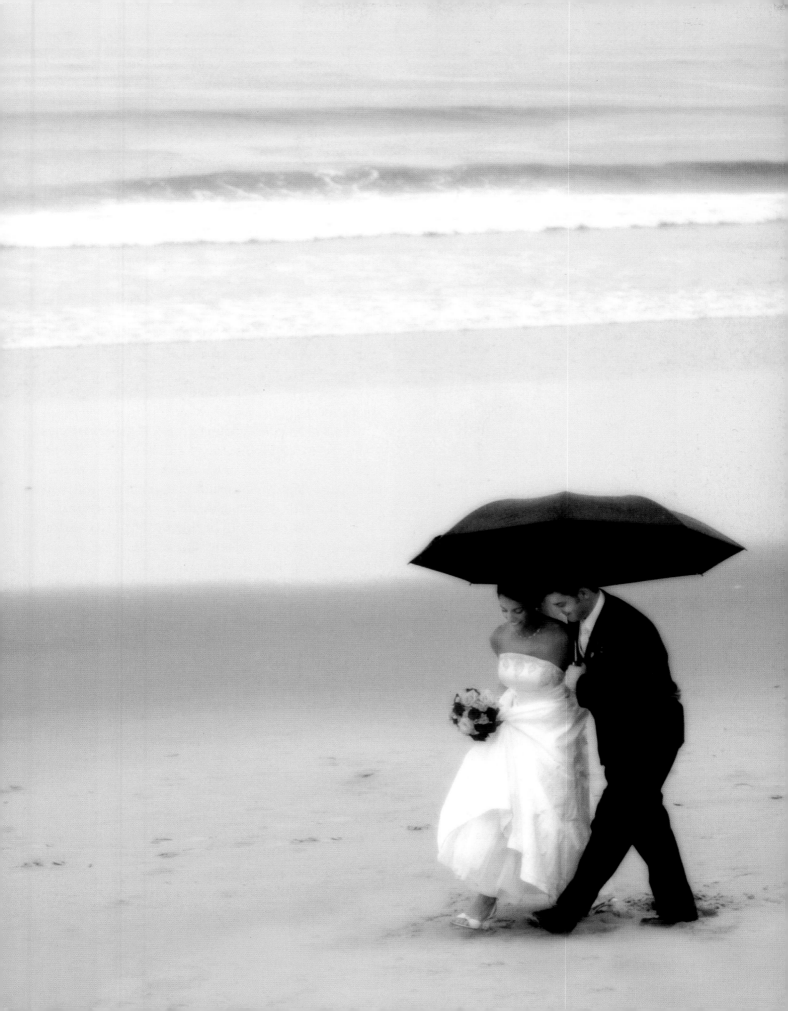

Fuzzy Duenkel is a master at manipulating daylight and converting it into soft and elegant studio-like lighting. Here, he used a free standing gold foil reflector (described below) to kick shade back onto his senior subject, creating a key light on her left side. You can see the catchlight in her eyes, which reveal the shape of the reflector.

Positioning. When the shadows produced by diffused light are harsh and deep, or even when you just want to add a little sparkle to the eyes of your subjects, you can use a large reflector—or even several reflectors. It helps to have an assistant (or several light stands with clamps) so that you can precisely set the reflectors. Be sure to position them outside the frame area.

You will have to adjust the reflector several times to create the right amount of fill-in, being sure to observe lighting effects from the camera position. Be careful about bouncing light in from beneath your subjects. Lighting coming from below the eye–nose axis is generally unflattering. Try to "focus" your reflectors (this really requires an assistant), so that you are only filling the shadows that need filling in.

With foil-type reflectors used close to the subjects, you can sometimes even overpower the ambient light, creating a pleasing and flattering lighting pattern.

Natural Reflectors. Many times nature provides its own fill-in light. Patches of sandy soil, light-colored shrubbery, or a nearby building may supply all the fill-in you'll need. Be careful, though that fill light directed upward from the ground onto your subject doesn't overpower the key light. Lighting coming from under the eye–nose axis is so unattractive that it's often called "ghoul light" (for obvious reasons).

Fuzzy Duenkel: Multi-Purpose Reflectors. Fuzzy Duenkel uses a homemade reflector he calls the "Fuzzyflector." It is basically two double-sided, 4x4-foot rigid reflectors hinged in the middle so that the unit will stand up. Because there are four sides, they can be used to produce four different levels of reflectivity. A Mylar surface provides a powerful reflector that can be aimed precisely to act as a key light in bright sun or an edge light from behind the subject. A spray-painted silver surface provides an efficient, color-balanced fill-in at close range. A white surface provides a softer fill and a black surface can be used for subtractive lighting effects. Because the reflector can be positioned in an L-shape to be freestanding, it can be used as a gobo and reflector simultaneously. Another way the reflector can be used is to position it beneath the subject's chin so that it reflects light up into the subject's face. If using a tripod, one plane of the reflector can be rested or taped to the tripod, or an assistant can be used to precisely position the fill.

Subtractive Lighting

Too-Diffuse Light. There are occasions when the light is so diffuse that it provides no modeling of the facial features. In other words, there is no dimension or direction to the light source. In these cases, you can place a black fill card (also called a gobo or flat) close to the subject to

block light from reaching crucial areas. The effect of this is to subtract light from the side of the subject on which it's used, effectively creating a stronger lighting ratio. This difference in illumination will show depth and roundness better than will the flat overall light.

Another instance where black reflectors come in handy is when you have two equally strong light sources, each powerful enough to be the key light. This sometimes happens when using direct sun and a Mylar reflector. The black reflector used close to one side or the other of the subject will reduce the intensity of the lighting, providing a much-needed lighting ratio.

Overhead Light. If you find a nice location for your portrait but the light is too overhead (creating dark eye sockets and unpleasant shadows under the nose and chin), you can use a gobo to block the overhead illumination. The light that strikes the subject then comes from either side and becomes the dominant light source. This lighting effect is like finding a porch or clearing to block the overhead light. There are two drawbacks to using an overhead gobo. First, you will need to have an assistant(s) along to hold the card in place over

the subject. Second, using the overhead card lowers the overall light level, meaning that you may have to shoot at a slower shutter speed or wider lens aperture than anticipated.

Diffusion Screens

Spotty Light. If you find an ideal location, but the light filtering through trees is a mixture of direct and diffused light (*i.e.*, spotty light), you can use a diffusion screen or

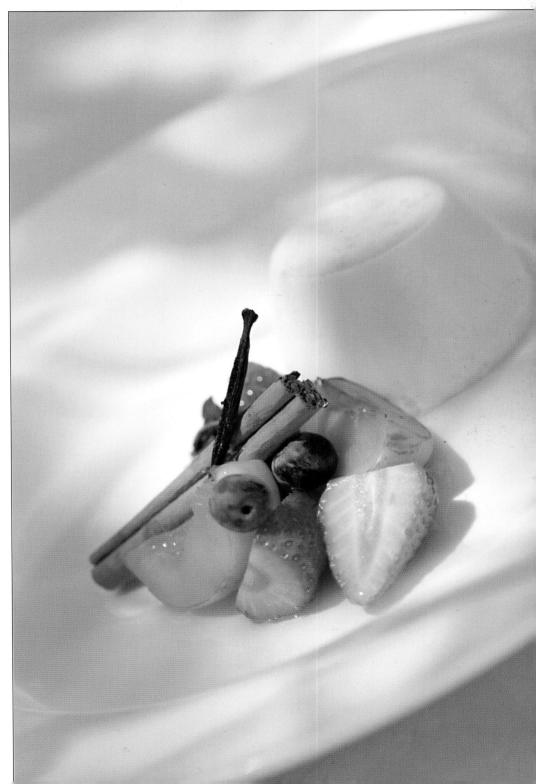

You would think that this delicate food shot by Mercury Megaloudis was shot in studio—but you'd be wrong. Mercury photographed this setup outdoors under a tree with filtered sunlight coming through the branches. He used a large, translucent water bottle next to the plate and fruit, which filtered and softened the light being transmitted. On the shadow side of the setup (to camera right), he used a small makeup mirror to redirect specular highlights onto the surface of the fruit. And toward the edge of the table on the shadow side, he used a large silvered reflector to open up the shadows and lower the overall light ratio on his still life subject.

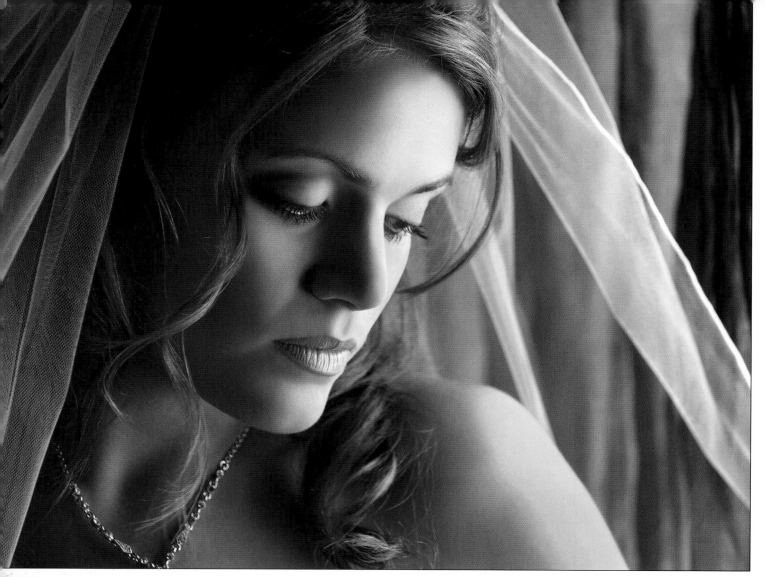

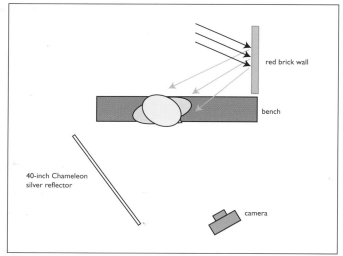

Professionals must know how to make great images in average lighting conditions. This formal bridal portrait was made on location with light reflected from a red and pink brick wall. The light, being warm-toned, required no filtration for color correction. A silver reflector was used to fill in the side of the face opposite the wall. Photo by Fran Reisner.

scrim held between the subject and the light source to provide directional but diffused lighting. Scrims are available commercially and come in sizes up to 6x8 feet. These devices are made of translucent material on a semi-rigid frame, so they need to be held by an assistant (or assistants) to be effectively used.

Direct Sunlight. Scrims are great when you want to photograph your subject in direct sunlight. Simply position the scrim between the light source and the subject to soften the available lighting. The closer the scrim is to the subject, the softer the lighting effect will be. As with window light, the Inverse Square Law (see page 18) applies to the light coming through a scrim. Light falls off fairly quickly once it passes through the scrim.

Backlighting. Another use for scrims is in combination with a reflector. With backlit subjects, the scrim can be held above and behind the subjects and a simple reflector used as fill-in for soft outdoor lighting. The soft

backlight causes a highlight rim around the subject, while the reflector, used close to the subject, provides a low lighting ratio and beautiful soft, frontal lighting.

Metering. Using a scrim will lower the amount of light on the subject, so meter the scene with the device held in place. Since the light quantity will be lower on your subject than the background and the rest of the scene, the background may be somewhat overexposed—not necessarily an unflattering effect. To minimize the effect and prevent the background from completely washing out, choose a dark-to-medium-colored background. This type of diffusion works best with head-and-shoulders portraits, since the size of the diffuser can be much smaller and held much closer to the subject.

Flash Techniques

X-Sync Speeds. All cameras with focal-plane shutters have an X-sync speed, the fastest speed at which you can fire the camera with a strobe attached. At speeds faster than the X-sync speed, only part of the frame will be exposed, because the shutter curtain will block off a portion of the frame. Modern SLRs and DSLRs have X-sync speeds up to $\frac{1}{500}$ second. (*Note:* Cameras with lens shutters, on the other hand, will sync with flash at any shutter speed.)

You can, of course, work at a shutter speed *slower* than the X-sync speed. This allows you to incorporate available light into the scene along with the flash. There is no limit to how slow a shutter speed you can use, but you may

Kevin Jairaj photographed this couple with available light and fill flash. Light was coming from camera left and from behind camera. The skin tones are warm because Kevin set the white balance on his Canon 20D to cloudy. The flash, just noticeable, adds a little fill and catchlights to the eyes. Kevin shoots in RAW mode so that he can increase the saturation and adjust the white balance if the image needs it. This image was exposed for $\frac{1}{45}$ second at f/2.8 at ISO 100.

ABOVE—Bill McIntosh is a big fan of barebulb flash used as a fill or main light at twilight. In this image, he underexposed the background by about one stop to bring out the dramatic clouds. The barebulb flash then becomes the key light and creates its own shadow when it overpowers the fill light, which is really the twilight. **RIGHT**—Leslie McIntosh captured this sunlight portrait on a windy beach in Virginia. The sun provided the primary lighting pattern and she used barebulb flash to fill in the shadows ever so slightly.

incur subject movement at very slow shutter speeds. In these situations, the sharply rendered subject will have an unnatural shadow around it, as if cut out from the background.

Fill Light. To measure and set the light output for a fill-in flash situation, begin by metering the scene. It is best to use a handheld incident meter with the hemisphere pointed at the camera from the subject position.

In this hypothetical example, the metered exposure is ⅟₁₅ second at f/8. Now, with a flashmeter, meter the flash only. Your goal is for the output to be one stop less than the ambient exposure. Adjust the flash output or flash-to-subject distance until your flash reading is f/5.6. Set the camera to ⅟₁₅ second at f/8. If using digital, a test exposure is a good idea.

Barebulb Fill. One of the most frequently used hand-held flash units is the barebulb flash, which acts more like a large point source light than a small portable flash. Instead of a reflector, these units use an upright flash tube sealed in a plastic housing for protection. Since there is no housing or reflector, barebulb flash provides 360-degree light coverage, meaning that you can use it with all of your wide-angle lenses. However, barebulb units produce a sharp, sparkly light, which is too harsh for almost every type of photography except outdoor portraits.

Light falloff is less than with other handheld units, making barebulb ideal for flash-fill—particularly outdoors. The trick is not to overpower the daylight. In each of Bill McIntosh's outdoor portraits, for instance, he uses barebulb flash to either fill-in backlit subjects or to add a little punch to sunlit subjects when the sun is very low, early in the morning or at sunset.

Barebulb units are predominantly manual flash units, meaning that you must adjust their intensity by changing the flash-to-subject distance or by adjusting the output.

Softbox Fill. Other photographers like to soften their fill-flash. Robert Love, for example, uses a Lumedyne strobe in a 24-inch softbox. He triggers the strobe cordlessly with a radio remote control. He often uses his flash at a 45-degree angle to his subjects (for small groups) for a modeled fill-in. For larger groups, he uses the softbox next to the camera for more even coverage.

TTL-balanced fill flash is extremely accurate with today's DSLRs and dedicated flash systems, even when a diffuser is placed over the flash head, as was done here. Cherie Steinberg Coté made this wonderful fashion portrait of a bride in a black veil on a downtown Los Angeles bridge. Her main lighting was Matrix-balanced fill flash with a Nikon D70 and SB-80 DX flash. These systems are so precise that you can set flash or exposure compensation in ⅓-stop increments and the system will defy your imagination with its uncanny accuracy, allowing the photographer to concentrate on creativity and not the nuts and bolts of on-location flash fill.

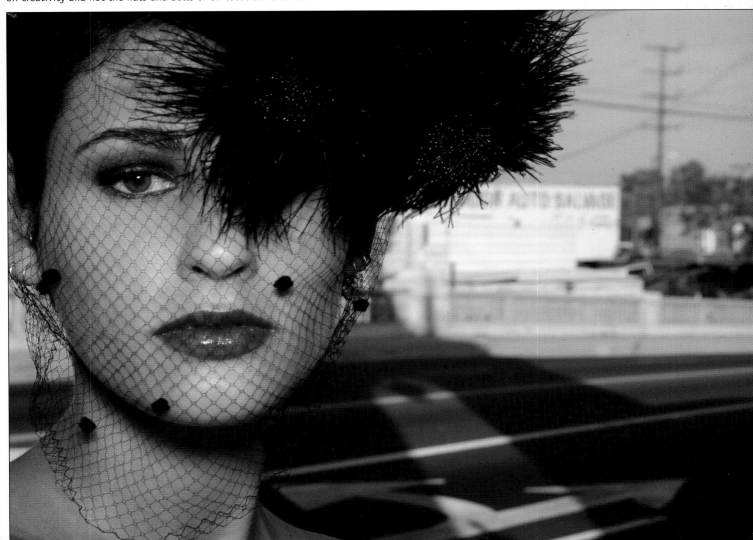

TTL Fill. Photographers shooting 35mm systems often prefer on-camera TTL flash. Many of these systems feature a mode that will adjust the flash output to the ambient-light exposure for balanced fill-flash. Many such systems also offer flash-output compensation that allows you to dial in full- or fractional-stop output changes for the desired ratio of ambient-to-fill illumination. They are marvelous systems and, more importantly, they are reliable and predictable. Some of these systems also allow you to remove the flash from the camera with a TTL remote cord.

Some of the latest digital SLRs and TTL flash systems allow you to set up remote flash units in groups, all keyed to the flash on the camera. You could, for instance, photograph a family group with four synced flashes remotely fired from the camera location, all producing the desired output for the predetermined flash-to-daylight ratio.

Flash-Fill with Studio Strobes. If you are using a studio-type strobe, the flash output can be regulated by ad-

LEFT—Strobe Slipper Plus shown with Pocket Wizard receiver mounted on PhotoFlex heavy-duty Swivel with PhotoFlex Adjustable Shoe Mount and Q39 X-small softbox. **BELOW**—Bruce Dorn has come up with a remote softbox that he uses on location called the Strobe Slipper (available from his website: www.idcphotography.com). The Photoflex softbox is small and maneuverable and uses a Canon (or Nikon) speedlight mounted to a stainless steel plate, which also holds a Pocket Wizard receiver. The wireless transmitter is mounted in the hotshoe of Dorn's Canon EOS 20D. The image here was made with a Strobe Slipper with the light used facing the model and allowed to wrap around her with no reflector. The strobe exposure was, naturally, balanced with the daylight exposure for a perfect combination of daylight and studio strobe.

Gene Martin photographed legendary sax player David "Fathead" Newman on top of a mountain outside Woodstock, NY. Gene made the shot with a Hasselblad 553ELX, 80mm Zeiss lens, and a Norman 200B with a ½ CTO filter to balance the flash with the ambient light.

justing the flash unit's power settings, which are usually fractional—½, ¼, ⅛, and so forth. If, for example, the daylight exposure is ¹⁄₆₀ second at f/8, you could set your flash output so that the flash exposure is f/5.6 or less to create good flash-fill illumination.

Flash Key. You may want to use your flash as a key light that overrides the ambient daylight. When doing so, it is best if the flash can be removed from the camera and positioned above and to one side of the subject. This will more closely imitate nature's light, which always comes from above and never head-on. Moving the flash to the side will improve the modeling qualities of the light and show more roundness in the face.

When adding flash as the key light, it is important to remember that you are balancing two light sources in one scene. The ambient light exposure will dictate the exposure on the background and the subjects. The flash exposure only affects the subjects. Knowing this, you can use the difference between the ambient and flash expo-

sures to darken the background and enhance the colors in it. However, it is unwise to override the ambient light exposure by more than two f-stops. This will cause a spotlight effect that will make the portrait appear as if it were shot at night.

Remember that electronic flash falls off in intensity rather quickly, so be sure to take your meter readings from the center of the subject area (and, with group portraits, from either end—just to be on the safe side). With a small group of three or four people you can get away with moving the strobe away from the camera to get better modeling—but not with larger groups, as the falloff is too great. You can, however, add a second flash of equal intensity and distance on the opposite side of the camera to help widen the light. If using two light sources, be sure to measure both flashes simultaneously for an accurate reading.

Flash Key with Direct Sun. If you are forced to shoot in direct sunlight (the background or location may be ir-

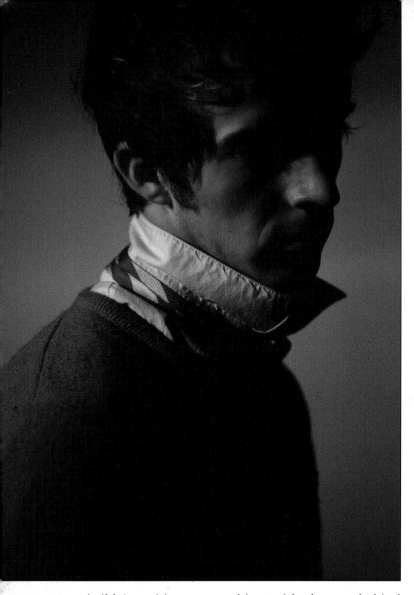

point-light source like the sun. Position the flash to the right or left of the subject and elevate it for better modeling. If you want to accentuate the lighting pattern and darken the background, increase the flash output to ½ to one stop greater than the daylight exposure and expose for the flash exposure. Do not underexpose your background by more than a stop, however, or you will produce an unnatural nighttime effect. Many times, this technique will allow you to shoot out in open shade without fear of creating shadows that hollow the eye sockets. The overhead nature of the diffused daylight will be overridden by the directional flash, which creates its own lighting pattern. To further refine the look, you can warm up the flash by placing a warming gel over the barebulb flash's clear shield. The gel will warm the facial lighting, but not the rest of the scene.

Painting with Light Outdoors

A friend of mine, who lives on one side of a canyon here in Southern California, collects flashlights—not little ones, but huge high-powered flashlights with which he can see the opposite side of the canyon at night, roughly a half mile away. His latest prize possession is a 3,000,000 candlepower unit that works like a lighthouse beacon, condensing the light and projecting it in a narrow beam across a vast distance.

With units like this, you can set up a scenic shot of a village, then walk through the town and light all of the buildings one by one, while your camera, which remains stationary with the shutter set on B, records each part of the scene as you cast light onto it. The trick with this type of photography is to extinguish the light when you change locations. Otherwise, you will be leaving a trail of light, like breadcrumbs, as you move from one location

resistible) position your subject with the sun behind them and use flash to create a frontal lighting pattern. The flash should be set to produce the same exposure as the daylight. The daylight will act like a background light and the flash, set to the same exposure, will act like a key light. Use the flash in a reflector or diffuser of some type to focus the light. If your exposure is ⅟₅₀₀ second at f/8, for example, your flash would be set to produce an f/8 on the subject. Position the flash to the side of the subject and elevate it for good facial modeling. An assistant or light stand will be called for in this setup. You may want to warm the flash output with a warming gel over the flash reflector. This is when DSLRs are handy.

Flash Key on Overcast Days. When the flash exposure and the daylight exposure are identical, the effect is like creating your own sunlight. This works particularly well on overcast days when using barebulb flash, which is a

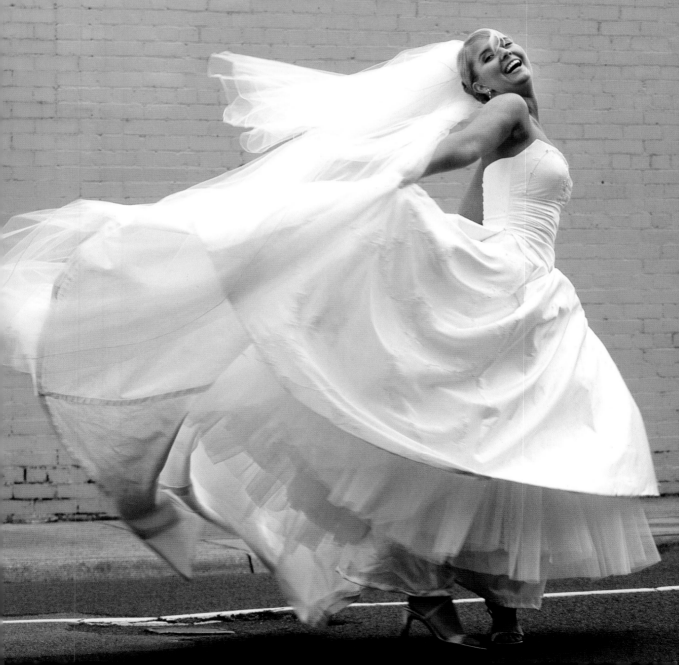

FUZZY DUENKEL: GARAGE LIGHT

Not long ago, photographer Fuzzy Duenkel started photographing seniors in their home garages. This is a location one would not expect to work well, but Fuzzy is adept at harnessing directional light and turning it into elegant portrait light. Fuzzy's senior portraits, which he does primarily on location at their homes, are rich with content. The garage is a museum of family heirlooms.

There are a couple of scenarios he uses. With a large open garage door, he gobos off much of the incoming light to prevent flare. Positioning the subject out of the way of the backlight, he uses a Mylar reflector to create the key light, harnessing the edge of the incoming available light.

In another garage-light scenario, he uses a small garage window as an edge light and positions his subject to take advantage of the powerful backlighting. He again positions his subject out of the way of the direct light coming from the open garage door and sets up a Mylar reflector to produce strong side lighting. See diagrams for more information.

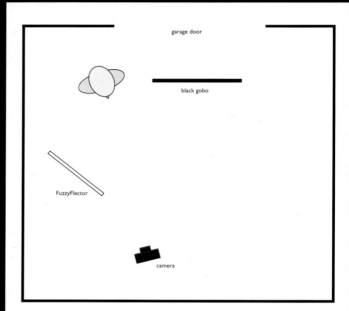

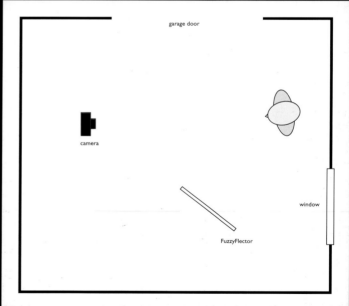

To the left and on the facing page are two examples of senior portraits done by Fuzzy Duenkel with garage light. Fuzzy is harnessing only available light, but because he uses such high-efficiency reflectors as his homemade Mylar FuzzyFlector, the light looks like studio lighting. Refer to the accompanying diagrams and see if you can follow the path of the main light source(s).

Drake Busath is a wedding and portrait photographer who knows exactly how to deal with daylight and backgrounds. Here, he chose a backlit location with beautiful trees set a good distance from the area of the sitting. He knocked the background out of focus by the use of a large aperture and with a little selective softening in Photoshop. He bent the backlight into a main light with the use of a large metallic reflector, which provided soft, warm, directional light that acted like a key light for all four family members. He brought his base exposure up a little to render detail in the blacks, but more importantly, to produce a higher key of skin tones. In backlit scenes it is much better to overexpose slightly—⅓ to ½ stop—than it is to underexpose by even a little bit.

to another. You must also be careful not to shine the light toward the camera lens, as all light sources will record on the film (or digital sensor) as specular highlights. You should always try to position your body between the light and the camera.

Controlling the Background

Depth of Field and Diffusion. For a portrait made in the shade, the best type of background is monochromatic. If the background is all the same color, the subjects will stand out from it. Problems arise when there

are patches of sunlight in the background. These light patches can be minimized by shooting at wide apertures. The shallow depth of field blurs the background so that light and dark tones merge. You can also use a diffuser over the camera lens to give your portrait an overall misty feeling. When you do so, you will also be minimizing a distracting background.

Retouching. Another way to minimize a distracting background is in retouching and printing. By burning-in or diffusing the background you make it darker, softer, or otherwise less noticeable. This technique is really simple in Photoshop, since it's fairly easy to select the subjects, invert the selection so that the background is selected, and perform all sorts of maneuvers on it—from diffusion and color correction to density correction. You can also add a transparent vignette of any color to visually subdue the background.

Subject-to-Background Distance. Some photographers, when working outdoors, prefer to place more space between group members to allow the background to become better integrated into the overall design.

Tonal Separation. One thing you must watch for outdoors is subject separation from the background. A dark-haired subject against a dark-green forest background will not separate, creating a tonal merger. Adding a background reflector to kick some light onto the hair would be a logical solution to such a problem.

Cool Skin Tones

A problem you may encounter is cool coloration in portraits taken in shade. If your subject is standing in a grove of trees surrounded by foliage, there is a good chance green will be reflected into the skin tones. Just as often, the foliage surrounding your subject in shade will reflect the cyan of an open blue sky.

In order to correct green or cyan coloration, you must first observe it. Your eyes will become accustomed to seeing the off-color rendering, so you will need to study the faces carefully—especially the coloration of the shadow areas of the face. If the color of the light is neutral, you will see gray in the shadows. If not, you will see either green or cyan.

Before digital capture, if you had to correct this coloration, you would use color-compensating (CC) filters over the lens. These are gelatin filters that fit in a filter holder. To correct the color shift, you would use the complimentary filter to neutralize the color balance of the light. With digital you only need to perform a custom white balance or use one of the camera's preprogrammed white balance settings, like "open shade." Those who use the ExpoDisc swear by its accuracy in these kinds of situations. By correcting the white balance, there is no need to color-correct the scene with filters.

There are times, however, when you want the light to be warm, not neutral. In these situations, you can use a gold-foil reflector to bounce warm light into the faces. The reflector does not change the color of the foliage or background, just the skin tones.

The Photographers

*T*he photographers whose work appears here represent the highest levels of lighting excellence. I want to thank all of the photographers for their participation in this book, but I would particularly like to thank Chris LaLonde from Ottawa, Canada; Virginian Bill McIntosh; and Fuzzy Duenkel from Wisconsin, who have been kind enough to provide truly useful technical information. All three have a unique and thorough grasp of lighting, each with a particular slant.

Barbara Bauer *(PPA Certified, M.Photog.Cr, PFA, ALPE, Hon. ALPE)*. Barbara is a graduate of Rhode Island School of Photography whose portraits have won numerous awards in local, state, national and international competitions.

Marcus Bell. Marcus's creative vision, natural style, and sensitivity have made him one of Australia's most revered photographers. His work has been published in *Black White, Capture, Portfolio Bride,* and countless bridal magazines.

Don Blair. For fifty years, the name Don Blair was synonymous with fine portraiture, craftsmanship and extraordinary contributions to the industry. It's no accident that he is among the most respected of all portrait photographers—and known to many as "Big Daddy."

Stacy Dail Bratton. Stacy is a studio owner and an accomplished children's and family photographer, having shot more than 2500 baby portraits over the years. She is a graduate of Art Center College of Design in Pasadena, CA.

Drake Busath *(Master Photographer, Craftsman)*. Drake Busath is a second-generation professional photographer who has spoken all over the world and has been featured in a wide variety of professional magazines. Drake also runs a popular photography workshop series in Northern Italy.

Anthony Cava *(BA, MPA, APPO)*. Anthony owns and operates Photolux Studio with his brother, Frank. At thirty years old, he became the youngest Master of Photographic Arts in Canada. Anthony also won WPPI's Grand Award with the first print he ever entered in competition.

Michael Costa. Michael is an award-winning photographer dedicated to producing only the best for his clients. He graduated with honors from the Brooks Institute in Santa Barbara, CA, where he received the coveted Departmental Award in the Still Photography program.

Cherie Steinberg Coté. Cherie began her photography career as a photojournalist and was the female freelance photographer at the *Toronto Sun.* Cherie currently lives in Los Angeles and has recently been published in the *L.A. Times, Los Angeles Magazine,* and *Towne & Country.*

Stephen A. Dantzig *(PsyD)*. Stephen is an award-winning photographer and the author of *Lighting Techniques for Fashion and Glamour Photography* and *Softbox Lighting Techniques for Professional Photographers,* both from Amherst Media.

Bruce Dorn. Twenty years of Hollywood filmmaking experience have shaped Bruce's cinematic style of photography. With his artistic partner and wife Maura Dutra, he owns iDC Photography, which specialized in wedding-day coverage for artistically-inclined clients.

Fuzzy Duenkel *(M.Photog., Cr., CPP)*. Fuzzy and Shirley Duenkel of West Bend, WI, operate a thriving portrait studio concentrating primarily on senior portraits. Fuzzy has had twelve prints selected for National Traveling Loan Collection, and one for Photokina in Germany.

Scott Eklund. Scott makes his living as a photojournalist for the *Seattle Post-Intelligencer,* but has also won numerous awards for his wedding photography, which relies on a newspaperman's sense of timing and storytelling.

Nancy Emmerich. Nancy is the wife of award-winning photographer Don Emmerich, and an award-winning portrait, wedding, and commercial photographer in her own right. The couple lecture extensively to professional photographers throughout the U.S. and abroad.

Fernando Escovar. A regular in *TV Guide* and *Motor Trend* magazines, Fernando shoots everything from exotic sports cars to Hollywood actresses and models. He has been

widely published and has recently introduced a series of educational DVDs, available at www.fotographer.com.

Gary Fagan. Gary, with his wife Jan, owns and operates an in-home studio in Dubuque, IA. Gary concentrates primarily on families and high-school seniors, using his half-acre outdoor studio as the main setting. In 2001, he was awarded WPPI's Accolade of Lifetime Excellence.

Deborah Lynn Ferro. A professional photographer since 1996, Deborah calls upon her background as a watercolor artist. She is a popular instructor and the author of *Artistic Techniques with Adobe Photoshop and Corel Painter,* from Amherst Media.

Rick Ferro. Rick has served as senior wedding photographer at Walt Disney World and received many awards from WPPI. He is the author of *Wedding Photography: Creative Techniques for Lighting and Posing,* and coauthor of *Wedding Photography with Adobe Photoshop,* both from Amherst Media.

Jerry Ghionis. Jerry Ghionis of XSiGHT Photography and Video is one of Australia's leading photographers, and his versatility extends to the wedding, portrait, fashion and corporate fields. In 2003, he won Wedding Album of the Year and the Grand Award in the Album competition at WPPI.

Al Gordon. Al operates a full-service studio and has photographed weddings throughout the Southeast. In addition to holding numerous degrees from PPA and WPPI, he received the coveted Kodak Trylon Gallery Award twice and has images in the prestigious ASP Masters Loan Collection.

Vincent Isola. Vincent specializes in fine art portraiture, weddings, commercial work, and event documentation. His business, Genesis Photography has a fully equipped in-house studio—one of the few available in the San Francisco region. To see more of Vincent's images, visit www.genesisphoto.com.

Kevin Jairaj. Kevin is a fashion photographer turned award-winning wedding and portrait photographer whose creative eye has earned him a stellar reputation in the Dallas/Fort Worth, TX area. His web site is: www.kjimages.com.

Claude Jodoin. Claude is an award-winning photographer from Detroit, MI. He is an event specialist, who also shoots numerous weddings and portrait sessions throughout the year. You can e-mail him at claudej1@aol.com.

Craig Kienast. Working in the small-market town of Clear Lake, IA, Kienast ordinarily gets more than double the fees of his nearest competitor (about $1200 for most of his high-school senior orders). Samples of Craig's work and teaching materials can be seen at www.photock.com.

Jeff Kolodny. Jeff began his career as a professional photographer in 1985 after receiving a BA in Film Production from Adelphi University in New York. Jeff recently relocated his business from Los Angeles to South Florida, where his goal is to produce cutting-edge digital wedding photography.

Christian LaLonde. Chris is a native of Ottawa, ONT, who operates the commercial division of Photolux Studios. He concentrates on corporate, architectural, food, product, and editorial jobs. In 2002 and 2003 he was awarded the prestigious Canadian Commercial Photographer of the Year.

Frances Litman. Frances is an award-winning photographer from Victoria, BC, who has been featured in publications by Kodak Canada and in FujiFilm advertising campaigns. She has also been honored with the prestigious Kodak Gallery Award.

Kersti Malvre. Kersti is well known for her unique style of portraiture that merges black & white with oil painting. She holds the PPA Photographic Craftsman's degree for outstanding contributions to the portrait profession.

Charles and Jennifer Maring. Charles and Jennifer own and operate Maring Photography Inc. in Wallingford, CT, which is also home to Rlab (www.resolutionlab.com), a digital lab for discriminating photographers.

Gene Martin. Gene Martin, who passed away in 2006, was a New York-based photographer best known for his conceptual portraiture of celebrities and music personalities for record companies and the editorial market. For *JazzTimes* alone, he shot over fifty covers.

Cliff Mautner. Cliff Mautner began his career as a photojournalist and never dreamed that he would be enjoying wedding photography as much as he does. His images have been featured in *Modern Bride, Elegant Wedding, The Knot,* and numerous other publications.

Mercury Megaloudis. Mercury Megaloudis is the owner of Megagraphics Photography in Strathmore, Victoria, Australia. The Australian Institute of Professional Photography awarded him the Master of Photography degree in 1999. He has won numerous awards in Australia and has recently begun winning competitions in the U.S. as well.

William S. McIntosh (*M.Photog.,Cr., F-ASP*). Bill McIntosh photographs executives and their families all over the U.S. and travels to England frequently on special assignments. He has lectured all over the world and is the author of *Classic Portrait Photography,* from Amherst Media.

Leslie McIntosh. Leslie holds a BFA from the Art Institute of Chicago and established a successful career in advertising and fashion photography before returning to Virginia Beach to join the family business. Today, she specializes in families, children, and high-school seniors.

Chris Nelson. After graduating from the University of Wisconsin in 1985 with a degree in English and Journalism,

Chris worked for six years as a photographer and reporter for the *Milwaukee Sentinel*. In 1991 he opened a studio, where he concentrates on lifestyle portraits with a photojournalistic edge.

Mark Nixon. Mark, who runs The Portrait Studio in Clontarf, Ireland, recently won Ireland's most prestigious photographic award with a panel of four wedding images. He is currently expanding his business to be international in nature and he is on the worldwide lecture circuit.

Larry Peters. Larry is one of the most successful and award-winning senior-portrait photographers in the nation. His popular web site is loaded with good information about photographing seniors: www.petersphotography.com

Norman Phillips *(AOPA)*. Norman is an acclaimed professional photographer and a frequent contributor to photographic publications. He is also the author of numerous books, including *Wedding and Portrait Photographers' Legal Handbook*, from Amherst Media.

Fran Reisner. Fran is an award-winning photographer from Frisco, TX. She is a Brooks Institute graduate and has been twice named Dallas Photographer of the Year. She is also a past president of the Dallas Professional Photographers Association.

J.B. and DeEtte Sallee. Sallee Photography has only been in business since 2003, but it has already earned many accomplishments. In 2004, J.B. received the first Hy Sheanin Memorial Scholarship through WPPI. In 2005, J.B. and DeEtte were also named Dallas Photographer of The Year.

Martin Schembri *(M.Photog. AIPP)*. Martin is an internationally recognized portrait, wedding, and commercial photographer who has conducted seminars on his unique style of creative photography all over the world.

Tim Schooler. Tim is an award-winning photographer specializing in high-school senior portraits with a cutting edge. Tim's work has been published internationally in magazines and books. His studio is located in Lafayette, LA. Visit his website: www.timschooler.com.

Michael Schuhmann. Michael is a highly acclaimed wedding photojournalist who believes in creating weddings with the style and flair of the fashion and bridal magazines. He has recently been the subject of profiles in *Rangefinder* and *Studio Photography & Design*.

Joseph and Louise Simone. Joseph and Louise have been a team since 1975, the year they established their Montreal studio. They are popular teachers who have lectured in France, Italy, Spain, Belgium, Germany, Austria, Martinique, Guadeloupe, and the United States.

Jeff Smith. Jeff is an award-winning portrait photographer who owns two studios in Central California. He is well recognized as a speaker, and the author of *Corrective Lighting, Posing, and Retouching Techniques,* from Amherst Media. He can be reached at: www.jeffsmithphoto.com.

Vicki and Jed Taufer. Vicki and Jed are the owners of V Gallery, a prestigious portrait studio in Morton, IL. Vicki has received national recognition for her portraits, and is an award winner in WPPI print competitions. Jed is the head of the imaging department at V Gallery.

Marc Weisberg. Marc Weisberg's interest in the culinary arts has led him to create numerous images for marketing and public relations campaigns, as well as images featured in *Wines and Spirits, Riviera, Orange Coast,* and *Where Los Angeles.*

David Clark Wendt. After years of shooting traditional commercial work and stock, Cincinnati photographer David has found his niche self-publishing calendars of slick cars, eighteen-wheelers, and steam locomotives. His work can be seen at www.wendtworldwide.com.

Jeffrey and Julia Woods. Jeffrey and Julia are award-winning wedding and portrait photographers who work as a team. They have won two Fuji Masterpiece awards and a Kodak Gallery Award. See more of their images at www.jwweddinglife.com.

Reed Young. Reed is a graduate of Brooks Institute who has focused his interests on fashion photography. Although he grew up in Minnesota, he is currently working out of New York. More of his work can be seen at www.reedyoung.com.

Yervant Zanazanian *(M. Photog. AIPP, F.AIPP)*. Yervant was born in Ethiopia, then lived and studied in Venice prior to settling in Australia. He now owns one of the country's most prestigious photography studios and has been Australia's Wedding Photographer of the Year three of the past four years.

Absorption. One of the characteristics of light. Absorption occurs when no light is transmitted or reflected from a surface. Absorption usually results in heat, but not light.

Angle of incidence. The original axis on which light travels. The angle of reflection is the secondary angle light takes when reflected off of some surface. The angle of incidence is equal to the angle of reflection.

Barebulb flash. A portable flash unit with a vertical flash tube that fires the flash illumination 360 degrees.

Barn doors. Black, metal folding doors that attach to a light's reflector. These are used to control the width of the beam of light.

Black flag. Light-blocking card that is supported on a stand or boom and positioned between the light source and subject to selectively block light from portions of the scene. Also known as a gobo.

Boom arm. A light stand accessory that uses a heavy counterweight on one end of a pole to balance the weight of a softbox or other light modifier.

Box light. A diffused light source housed in a box-shaped reflector. The bottom of the box is translucent material; the side pieces of the box are opaque, but they are coated with a reflective material such as foil on the inside to optimize output.

Bounce flash. Bouncing the light of a studio or portable flash off a surface such as a ceiling or wall to produce indirect, shadowless lighting.

Broad lighting. One of two basic types of portrait lighting in which the key light illuminates the side of the subject's face turned toward the camera.

Burning-in. A darkroom technique in which specific areas of the print surface are given additional exposure in order to darken them. Emulated in Photoshop.

Burst rate. The number of frames per second (fps) a digital camera can record images and the number of frames per exposure sequence it can record. Typical burst rates range from 2.5fps up to six shots, all the way up to 8fps up to forty shots.

Butterfly lighting. One of the basic portrait lighting patterns, characterized by a high key light placed directly in line with the line of the subject's nose. This lighting produces a butterfly-like shadow under the nose. Also called paramount lighting.

Catchlight. The specular highlights that appear in the iris or pupil of the subject's eyes, reflected from the portrait lights.

CC filters. Color-compensating filters that come in gel or glass form and are used to correct the color balance of a scene.

CF card reader. A device used to connect a CF card or microdrive to a computer. CF card readers are used to download image files from a capture and/or storage device to your computer workstation.

CMOS (Complementary Metal Oxide Semiconductor). A type of semiconductor that has been, until the Canon EOS D30, widely unavailable for digital cameras. CMOS chips are less energy consuming than other chips that utilize simply one type of transistor.

Color temperature. The degrees Kelvin of a given light source. Also refers to a film's sensitivity. Color films are balanced for either 5500K (daylight), 3200K (tungsten), or 3400K (photoflood).

Cove. A seamless backdrop or lighting table with no horizon line. The angle where horizontal and vertical planes intersect is curved.

Cross lighting. Lighting that comes from the side of the subject, skimming facial surfaces to reveal the maximum texture in the skin. Also called sidelighting.

Cross shadows. Shadows created by lighting a group with two light sources from either side of the camera. These should be eliminated to restore the "one-light" look.

Depth of field. The distance that is sharp beyond and in front of the focus point at a given f-stop.

Diffusion flat. Portable, translucent diffuser that can be positioned in a window frame or near the subject to diffuse the light striking the subject. Also known as a scrim.

Dodging. Darkroom printing technique or Photoshop technique in which specific areas of the print are given less print exposure by blocking the light to those areas of the print, making those areas lighter.

Dots. Small circular black cards attached to stiff wire stems held in place with a C-stand or other support to block light from reaching certain areas of the scene. These miniature gobos are sometimes used in small product lighting setups. Also known as fingers.

Dragging the shutter. Using a shutter speed slower than the X sync speed in order to capture the ambient light in a scene.

Fashion lighting. Type of lighting that is characterized by its shadowless light and its proximity to the lens axis. Fashion lighting is usually head-on and very soft in quality.

Feathered edge. Also known as the penumbra; the soft edge of the circular light pattern from a light in a parabolic reflector.

Feathering. Misdirecting the light deliberately so that the edge of the beam of light illuminates the subject.

Fill card. A white or silver-foil-covered card used to reflect light back into the shadow areas of the subject.

Fill light. Secondary light source used to fill in the shadows created by the key light.

Fingers. *See* Dots.

Flash-fill. Flash technique that uses electronic flash to fill in the shadows created by the main light source.

Flashing. A darkroom technique used in printing to darken an area of the print by exposing it to raw light. The same technique can be achieved in Photoshop using a transparent vignette.

Flash-key. Flash technique in which the flash becomes the main light source and the ambient light in the scene fills the shadows created by the flash.

Flashmeter. A handheld incident light meter that measures both the ambient light of a scene and when connected to an electronic flash, will read flash only or a combination of flash and ambient light. They are invaluable for determining outdoors flash exposures and lighting ratios.

Flat. A large white or gray reflector usually on casters that can be moved around a set for bouncing light onto the set or subject.

Focusing an umbrella. Adjusting the length of the exposed shaft of an umbrella in a light housing to optimize light output.

45-degree lighting. Portrait lighting pattern characterized by a triangular highlight on the shadow side of the face. Also known as Rembrandt lighting.

Fresnel lens. The glass filter on a spotlight that concentrates the light rays in a spotlight into a narrow beam of light.

Full-length portrait. A pose that includes the full figure of the model. Full-length portraits can show the subject standing, seated or reclining.

Gaussian blur. Photoshop filter that diffuses a digital image.

Gobo. Light-blocking card that is supported on a stand or boom and positioned between the light source and subject to selectively block light from portions of the scene.

Grayscale. Color model consisting of up to 254 shades of gray plus absolute black and absolute white. Every pixel of a grayscale image displays as a brightness value ranging from 0 (black) to 255 (white). The exact range of grays represented in a grayscale image can vary.

Groundglass. The camera's focusing screen on which the image is focused.

Head-and-shoulder axis. Imaginary lines running through shoulders (shoulder axis) and down the ridge of the nose (head axis). Head-and-shoulder axes should never be perpendicular to the line of the lens axis.

High-key lighting. Type of lighting characterized by low lighting ratio and a predominance of light tones.

Highlight brilliance. Refers to the specularity of highlights on the skin. A negative with good highlight brilliance shows specular highlights (paper base white) within a major highlight area. Achieved through good lighting and exposure techniques.

Histogram. A graph associated with a single image file that indicates the number of pixels that exist for each brightness level. The range of the histogram represents 0 to 255 from left to right, with 0 indicating "absolute" black and 255 indicating "absolute" white.

Hot spots. A highlight area of the negative that is overexposed and without detail. Sometimes these areas are etched down to a printable density.

Incident light meter. A handheld light meter that measures the amount of light falling on its light-sensitive dome.

Inverse Square Law. A behavior of light that defines the relationship between light and intensity at varying distances. The Inverse Square Law states that the illumination is inversely proportional to the square of the distance from the point source of light.

JPEG (Joint Photographic Experts Group). JPEG is an image file format with various compression levels. The higher the compression rate, the lower the image quality, when the file is expanded (restored). Although there is a form of JPEG that employs lossless compression, the most commonly used

forms of JPEG employ lossy compression algorithms, which discard varying amounts of the original image data in order to reduce file storage size.

Key light. The main light in portraiture used to establish the lighting pattern and define the facial features of the subject.

Kicker. A backlight (a light coming from behind the subject) that highlights the hair or contour of the body.

Levels. In Photoshop, Levels allows you to correct the tonal range and color balance of an image. In the Levels window, Input refers to the original intensity values of the pixels in an image and Output refers to the revised color values based on your adjustments.

Lighting ratio. The difference in intensity between the highlight side of the face and the shadow side of the face. A 3:1 ratio implies that the highlight side is three times brighter than the shadow side of the face.

Loop lighting. A portrait lighting pattern characterized by a loop-like shadow on the shadow side of the subject's face. Differs from paramount or butterfly lighting because the main light is slightly lower and farther to the side of the subject.

Low-key lighting. Type of lighting characterized by a high lighting ratio and strong scene contrast as well as a predominance of dark tones.

Main light. Synonymous with key light.

Modeling light. A secondary light mounted in the center of a studio flash head that gives a close approximation of the lighting that the flash tube will produce. Usually high intensity, low-heat output quartz bulbs.

Monolight. A studio-type flash that is self-contained, with its own capacitor and discharge circuitry. Monolights come with internal Infrared triggers so the light can be fired without directly connecting the flash to a camera or power pack.

Over-lighting. Main light is either too close to the subject, or too intense and over-saturates the skin with light, making it impossible to record detail in highlighted areas. Best corrected by feathering the light or moving it back.

Parabolic reflector. Oval-shaped dish that houses a light and directs its beam outward in an even controlled manner.

Paramount lighting. One of the basic portrait lighting patterns, characterized by a high key light placed directly in line with the line of the subject's nose. This lighting produces a butterfly-like shadow under the nose. Also called butterfly lighting.

Penumbra. The soft edge of the circular light pattern from a light in a parabolic reflector. It is also known as the feathered edge of the undiffused light source.

Pixel (picture element). Smallest element used to form an image on a screen or paper. Thousands of pixels are used to display an image on a computer screen or print an image from a printer.

Point light source. A sharp-edged light source like the sun, which produces sharp-edged shadows without diffusion.

RAW. A file format, which uses lossless compression algorithms to record picture data as is from the sensor, without applying any in-camera corrections. In order to use images recorded in the RAW format, files must first be processed by compatible software. RAW processing includes the option to adjust exposure, white balance and the color of the image, all the while leaving the original RAW picture data unchanged.

Reciprocity Failure. A characteristic of film. Reciprocity failure is a decrease in light sensitivity with increased or decreased length of exposure. Typically, all exposure settings are reciprocal between $\frac{1}{2}$ second and $\frac{1}{8,000}$ second. Outside of that range the film loses sensitivity and additional exposure and color correction must be applied, depending on individual emulsion characteristics.

Reflected light meter. A meter that measures the amount of light reflected from a surface or scene. All in-camera meters are of the reflected type.

Reflection. One of the behaviors of light. Light striking an opaque or semi-opaque surface will either reflect light at various angles, transmit light through the surface or be absorbed by the surface.

Reflector. 1) Same as fill card. 2) A housing on a light that reflects the light outward in a controlled beam.

Refraction. When light is transmitted through a surface, it changes speed and is misdirected at an angle different from its incident angle. Different surfaces bend or refract light in known quantities. The definition of a given material's refractive characteristics is known as its refractive index.

Rembrandt lighting. Same as 45-degree lighting.

Rim lighting. Portrait lighting pattern where the key light is behind the subject and illuminates the edge of the subject. Most often used with profile poses.

Seven-eighths view. Facial pose that shows approximately $\frac{7}{8}$ of the face. Almost a full-face view as seen from the camera.

Scatter. A characteristic of light. When light is transmitted through a translucent medium in changes directions and is transmitted at a wide variety of different angles. The transmitted light is known as scatter.

Scrim. A panel used to diffuse sunlight. Scrims can be mounted in panels and set in windows, used on stands, or they can be suspended in front of a light source to diffuse the light.

Shadow. An area of the scene on which no direct light is falling making it darker than areas receiving direct light (*i.e.* highlights).

Shadow edge. Where a highlight and shadow meet on a surface is the shadow edge. With hard light, the shadow edge is abrupt. With soft light the shadow edge is gradual. Also known as the transfer edge.

Sharpening. In Photoshop, filters that increase apparent sharpness by increasing the contrast of adjacent pixels within an image.

Short lighting. One of two basic types of portrait lighting in which the key light illuminates the side of the face turned away from the camera.

Slave. A remote triggering device used to fire auxiliary flash units. These may be optical, or radio-controlled.

Snoot. A conical accessory that attaches to a light housing's reflector and narrows the beam of light. Snoots allow the illumination of very small areas with relatively bright light.

Softbox. Same as a box light. Can contain one or more light heads and single or double-diffused scrims.

Specular highlights. Sharp, dense image points on the negative. Specular highlights are very small and usually appear on pores in the skin. Specular highlights are pure white with no detail.

Split lighting. Type of portrait lighting that splits the face into two distinct areas: shadow side and highlight side. The key light is placed far to the side of the subject and slightly higher than the subject's head height.

Spotmeter. A handheld reflected light meter that measures a narrow angle of view—usually from 1 to 4 degrees.

Spots. Spotlights; a small sharp light that uses a Fresnel lens to focus the light from the housing into a narrow beam.

sRGB. Color matching standard jointly developed by Microsoft and Hewlett-Packard. Cameras, monitors, applications, and printers that comply with this standard are able to reproduce colors the same way. Also known as a color space designated for digital cameras.

Straight flash. The light of an on-camera flash unit that is used without diffusion (*i.e.*, straight).

Subtractive fill-in. Lighting technique that uses a black card to subtract light out of a subject area in order to create a better defined lighting ratio. Also refers to the placement of a black card over the subject in outdoor portraiture to make the light more frontal and less overhead in nature.

Sweep table. A translucent table for lighting small products and still lifes. It is characterized by a curved horizon line so that objects can be photographed with a seamless background.

TTL-balanced fill-flash. Flash exposure systems that read the flash exposure through the camera lens and adjust flash output to compensate for flash and ambient light exposures, producing a balanced exposure.

Three-quarter-length pose. Pose that includes all but the lower portion of the subject's anatomy. Can be from above knees and up, or below knees and up.

Three-quarters view. Facial pose that allows the camera to see ¾ of the facial area. Subject's face is usually turned 45 degrees away from the lens so that the far ear disappears from camera view.

TIFF (Tagged Image File Format). File format commonly used for image files. There are several kinds of TIFF files. TIFF files are lossless, meaning that no matter how many times they are opened and closed, the data remains the same, unlike JPEG files, which are designated as lossy files, meaning that data is lost each time the files are opened and closed.

Transfer edge. *See* Shadow edge.

Umbrella lighting. Type of soft, casual lighting that uses one or more photographic umbrellas to diffuse the light source(s).

Umbra. The hot center portion of the light pattern from an undiffused light in a parabolic reflector.

Unsharp mask. A sharpening tool in Adobe Photoshop that is usually the last step in preparing an image for printing.

Vignette. A soft-edged border around the main subject. Vignettes can be either light or dark in tone and can be included at the time of shooting, or added later in printing.

Watt-seconds (Ws). Numerical system used to rate the power output of electronic flash units. Primarily used to rate studio strobe systems.

White balance. The camera's ability to correct color and tint when shooting under different lighting conditions including daylight, indoor and fluorescent lighting.

Wraparound lighting. Soft type of light, produced by umbrellas, that wraps around the subject, producing a low lighting ratio and open, well-illuminated highlight areas.

X sync. The shutter speed at which focal-plane shutters synchronize with electronic flash.

Zebra. A term used to describe reflectors or umbrellas having alternating reflecting materials such as silver and white cloth.

Index

CHILDREN'S PORTRAIT PHOTOGRAPHY HANDBOOK

Bill Hurter

Packed with inside tips from industry leaders, this book shows you the ins and outs of working with some of photography's most challenging subjects. $34.95 list, 8.5x11, 128p, 175 color images, index, order no. 1840.

THE BEST OF PROFESSIONAL DIGITAL PHOTOGRAPHY

Bill Hurter

Digital imaging has a stronghold on photography. This book spotlights the methods that today's photographers use to create their best images. $34.95 list, 8.5x11, 128p, 180 color photos, 20 screen shots, index, order no. 1824.

WEDDING PHOTOGRAPHER'S HANDBOOK

Bill Hurter

Learn to produce images with technical proficiency and superb, unbridled artistry. Includes images and insights from top industry pros. $34.95 list, 8.5x11, 128p, 180 color photos, 10 screen shots, index, order no. 1827.

RANGEFINDER'S PROFESSIONAL PHOTOGRAPHY

edited by Bill Hurter

Editor Bill Hurter shares over one hundred "recipes" from *Rangefinder's* popular cookbook series, showing you how to shoot, pose, light, and edit fabulous images. $34.95 list, 8.5x11, 128p, 150 color photos, index, order no. 1828.

THE BEST OF PHOTOGRAPHIC LIGHTING

Bill Hurter

Top professionals reveal the secrets behind their successful strategies for studio, location, and outdoor lighting. Packed with tips for portraits, still lifes, and more. $34.95 list, 8.5x11, 128p, 150 color photos, index, order no. 1808.

MARKETING & SELLING TECHNIQUES
FOR DIGITAL PORTRAIT PHOTOGRAPHY

Kathleen Hawkins

Great portraits aren't enough to ensure the success of your business! Learn how to attract clients and boost your sales. $34.95 list, 8.5x11, 128p, 150 color photos, index, order no. 1804.

THE PHOTOGRAPHER'S GUIDE TO
COLOR MANAGEMENT
PROFESSIONAL TECHNIQUES FOR CONSISTENT RESULTS

Phil Nelson

Learn how to keep color consistent from device to device, ensuring greater efficiency and more accurate results. $34.95 list, 8.5x11, 128p, 175 color photos, index, order no. 1838.

MASTER'S GUIDE TO WEDDING PHOTOGRAPHY
CAPTURING UNFORGETTABLE MOMENTS AND LASTING IMPRESSIONS

Marcus Bell

Learn to capture the unique energy and mood of each wedding and build a lifelong client relationship. $34.95 list, 8.5x11, 128p, 200 color photos, index, order no. 1832.

MASTER LIGHTING GUIDE
FOR COMMERCIAL PHOTOGRAPHERS

Robert Morrissey

Use the tools and techniques pros rely on to land corporate clients. Includes diagrams, images, and techniques for a failsafe approach for shots that sell. $34.95 list, 8.5x11, 128p, 110 color photos, 125 diagrams, index, order no. 1833.

SOFTBOX LIGHTING TECHNIQUES
FOR PROFESSIONAL PHOTOGRAPHERS

Stephen A. Dantzig

Learn to use one of photography's most popular lighting devices to produce soft and flawless effects for portraits, product shots, and more. $34.95 list, 8.5x11, 128p, 260 color images, index, order no. 1839.

JEFF SMITH'S LIGHTING FOR OUTDOOR AND LOCATION PORTRAIT PHOTOGRAPHY

Learn how to use light throughout the day—indoors and out—and make location portraits a highly profitable venture for your studio. $34.95 list, 8.5x11, 128p, 170 color images, index, order no. 1841.

MASTER POSING

FOR CHILDREN'S PORTR

Norman Phillips

Create perfect portraits of
teens. Includes technique
and floor poses for boys ar
groups. $34.95 list, 8.5
images, order no. 1826.

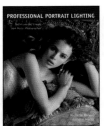

PROFESSIONAL PORTRAIT LIGHTING

TECHNIQUES AND IMAGES FROM MASTER PHOTOGRAPHERS

Michelle Perkins

Get a behind-the-scenes look at the lighting techniques employed by the world's top portrait photographers. $34.95 list, 8.5x11, 128p, 200 color photos, index, order no. 2000.

PROFESSIONAL PORTRAIT POSING

TECHNIQUES AND IMAGES FROM MASTER PHOTOGRAPHERS

Michelle Perkins

Learn how master photographers pose subjects to create unforgettable images. $34.95 list, 8.5x11, 128p, 175 color images, index, order no. 2002.

ARTISTIC TECHNIQUES WITH ADOBE® PHOTOSHOP® AND COREL® PAINTER®

Deborah Lynn Ferro

Flex your creativity and learn how to transform photographs into fine-art masterpieces. Step-by-step techniques make it easy! $34.95 list, 8.5x11, 128p, 200 color images, index, order no. 1806.

DIGITAL PHOTOGRAPHY BOOT CAMP

Kevin Kubota

Kevin Kubota's popular workshop is now a book! A down-and-dirty, step-by-step course in building a professional photography workflow and creating digital images that sell! $34.95 list, 8.5x11, 128p, 250 color images, index, order no. 1809.

POSING FOR PORTRAIT PHOTOGRAPHY

A HEAD-TO-TOE GUIDE

Jeff Smith

Author Jeff Smith teaches surefire techniques for fine-tuning every aspect of the pose for the most flattering results. $34.95 list, 8.5x11, 128p, 150 color photos, index, order no. 1786.

...UCKER'S **PORTRAIT ...OGRAPHY HANBOOK**

...nally acclaimed portrait photog-rapher
...ucker takes you behind the scenes and
...u how to create a "Monte Portrait."
...othing selection, posing, lighting, and
...re—with techniques for both studio and
...shoots. $34.95 list, 8.5x11, 128p, 200
color photos, index, order no. 1846.

PROFESSIONAL MODEL PORTFOLIOS

A STEP-BY-STEP GUIDE FOR PHOTOGRAPHERS

Billy Pegram

Learn to create portfolios that will get your clients noticed—and hired! $34.95 list, 8.5x11, 128p, 100 color images, index, order no. 1789.